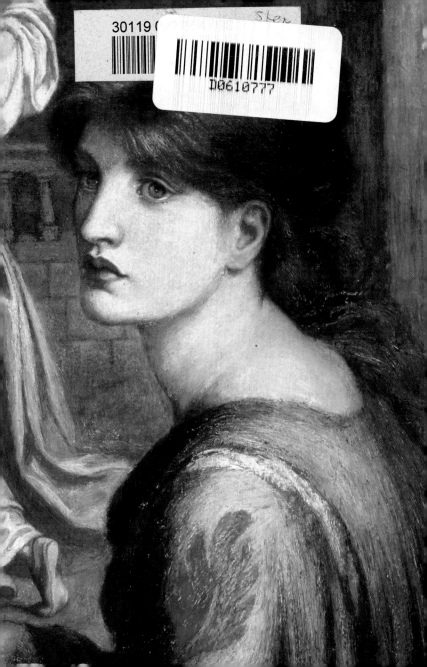

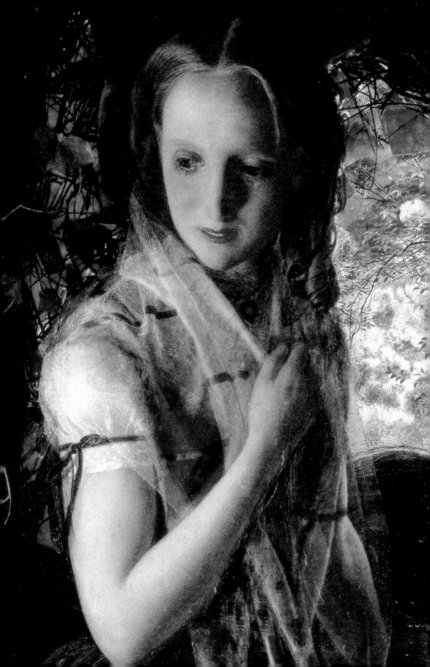

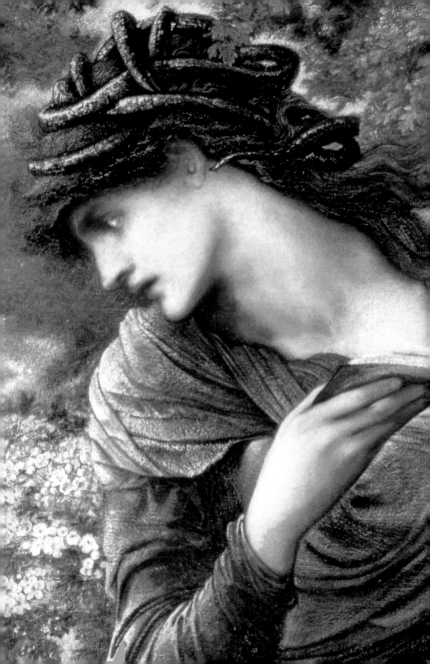

CONTENTS

THE PRE-RAPHAELITES
ROMANCE AND REALISM
Laurence des Cars

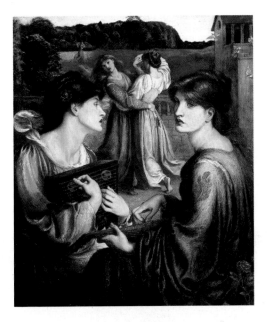

 Thames & Hudson

'Go to Nature in all singleness of heart, and walk with her laboriously and trustingly, having no other thought but how best to penetrate her meaning, and remember her instruction, rejecting nothing, selecting nothing and scorning nothing; believing all things to be right and good, and rejoicing always in the truth.'

John Ruskin
Modern Painters, vol. 1, 1843

CHAPTER 1

A VICTORIAN REBELLION

The Eve of St Agnes by Holman Hunt (1848; opposite, detail) prefigures the Pre-Raphaelites' aesthetic preferences, with its theme inspired by a poem by Keats and its archaizing realism. The drawing by Arthur Hughes (right), after a sketch by Hunt, reflects the friendship between the members of the group when it was formed.

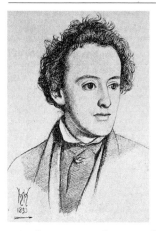

The art critic John Ruskin (1819–1900) recounted how, in early September 1848, seven young men – six artists and one writer – met in the Bloomsbury studio of John Everett Millais at 83 Gower Street, London. They gave themselves the 'unfortunate and somewhat ludicrous name of "Pre-Raphaelite Brethren"'. This rather mixed group was dominated by three artists – Millais (1829–96), William Holman Hunt (1828–1910) and Dante Gabriel Rossetti (1828–82) – in the early years. Born out of a rather confused youthful idealism, the movement rapidly gained momentum and had a profound effect on Victorian artistic life.

At the Royal Academy Schools

John Everett Millais came from a well-to-do Jersey family. Thanks to his precocious talent in drawing and painting, which his family encouraged, he was admitted to the Royal Academy Schools in 1840 at the age of eleven, making him the youngest student ever accepted. Yet he was very unhappy with the academic way of teaching and soon joined forces with a group of artists who were openly calling for reform. One of them was William Holman Hunt, who entered the Royal Academy Schools in 1844. Coming from a much more humble background, Hunt had a hard time persuading his family of his artistic vocation.

Dante Gabriel Rossetti was the son of an Italian political refugee exiled from the kingdom of Naples, a professor of Italian at

As very close friends, the Pre-Raphaelites often depicted each other, in paintings and drawings and sometimes also in caricatures. On 7 May 1853 Rossetti wrote to the Scottish poet and painter William Bell Scott: 'On the 12th of April, the P. R. B. [Pre-Raphaelite Brothers] all made portraits of each other, which have been forwarded to Woolner.' Hunt drew the portrait of Millais (1853; above left) in a very precise and elegant style. Rossetti depicted Hunt in an intense and rather sombre drawing (opposite below) that reflects his taste for introspection already evident in his self-portrait (below), still full of Romantic spirit, dating from March 1847.

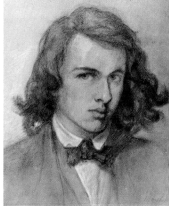

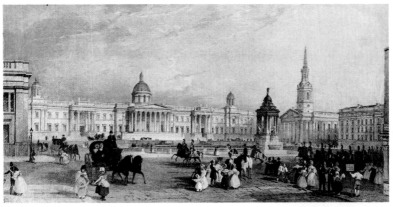

King's College, London, and a specialist on Dante, which explains the name he gave his son and perhaps the enthusiasm the young Dante Gabriel soon developed for the eponymous Italian poet. His mother, Frances Polidori, encouraged the intellectual talents of her four children, Maria, Dante Gabriel, William Michael and Christina. Dante Gabriel, a young man well versed in Romantic literature but a very lazy student – the early years of his career were hampered by his poor painting technique – had already begun his major work translating Italian 13th- and 14th-century poets when the Brotherhood was formed.

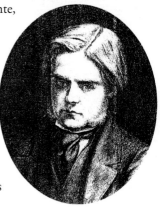

In the spring and summer of 1848 Millais, Hunt and Rossetti also took part in the short-lived Cyclographic Society, a sketching club based on mutual criticism during which many of the Pre-Raphaelites' ideas probably took form. The trio admitted four friends to their group, perhaps to bring it up to the magic number of seven: Thomas Woolner (1825–92), a sculptor and poet who tried to apply their ideas to sculpture; James Collinson (1825–81), another Royal Academy Schools student who was briefly engaged to Christina Rossetti; William Michael Rossetti (1829–1919), who had virtually no

When the young artists who founded the Pre-Raphaelite Brotherhood attended the Royal Academy Schools, the premises were located in the right wing of the National Gallery in Trafalgar Square (above). The Schools moved to Burlington House, Piccadilly, in 1869.

artistic experience – at the time he was a clerk in the Inland Revenue – and became the movement's chronicler; and lastly, Frederic George Stephens (1828–1907) who was finding it rather difficult to learn to paint and turned a few years later to writing on art and to art criticism, becoming one of the foremost observers of the Victorian art world.

Rebellion on all fronts

The significance of this first meeting of the Pre-Raphaelite Brotherhood can be understood only in the context of intellectual and artistic life in Europe and England at the beginning of the Victorian period. The Brotherhood came into being at a time when Europe was flourishing politically and socially. It was formed at the end of what were known as the Hungry Forties in England, a time of social protest, which culminated on 10 April 1848 in one of the last great Chartist demonstrations. In 1836 the People's Charter marked the birth of a national workers' movement in England which called for universal suffrage and voting by secret ballot. Millais and Hunt joined in the famous march from Russell Square to Kennington Common, although their rebellion at that period was primarily aesthetic. The small group all rejected academic conventions and wanted to revitalize both the style and the content of English painting.

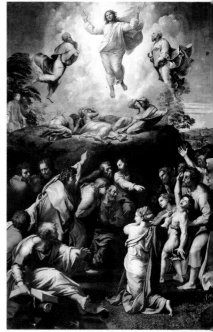

Victorian painting or the triumph of genre painting

When Queen Victoria came to the throne in 1837, genre painting, which had become extremely popular, dominated English art

between 1830 and 1840. This situation is understandable in a country that never had much liking for historical painting and tended to draw on the tradition of art depicting scenes from everyday life, as in 17th-century Dutch and Flemish paintings. In literature it was the golden age of the novel, with writers such as Sir Walter Scott, Charles Dickens and William Thackeray. Similarly, narrative painting, with artists such as David Wilkie, William Mulready and William Powell Frith, described everything in minute detail and adopted a deliberately moralizing tone that sometimes led to the most cloying sentimentalism. In this flourishing industrial and commercial society, the great technical perfection of these works was regarded as a guarantee of hard work and therefore also of quality, which partly explains their success. In short, English painting, bogged down in convention and repetition, was ready to be roused from an ennui that became more patent year by year at the Royal Academy summer exhibitions.

Hidebound academic teaching

The Pre-Raphaelites blamed this creative impasse on academic teaching, based on what they saw as perverted or mistaken theories. Their harsh, and at times unfair, criticism focused especially on Raphael's *Transfiguration* in the Vatican, a copy of which was exhibited at the National Gallery during the 1840s. In 1905 Hunt attacked it as 'a painting which should be condemned for its grandiose disregard of the

•The traditions that went through the Bolognese Academy, which were introduced at the foundation of all later schools…were lethal in their influence, tending to stifle the breath of design,• (Hunt, 1905). On that basis, Raphael's *Transfiguration* (c. 1518; opposite below) was regarded as the prime example of an art constrained by rules and regulations, which had led in early 19th-century England to the prevalence of repetitive and unimaginative genre painting, as in *Grace Before Meat* by David Wilkie (1839; above centre).

The Pre-Raphaelites had nothing but disdain for Sir Joshua Reynolds (self-portrait, above) whom they nicknamed 'Sir Sloshua' in a play on words on his first name and his 'sloshy' technique. He was the first president of the Royal Academy, founded in 1768.

simplicity of truth, the pompous posturing of the Apostles, and the unspiritual attitudinizing of the Saviour'. Rubens was another of their *bêtes noires*: beside every reference to Rubens, Rossetti wrote 'Spit here!'. The Pre-Raphaelites wanted to revitalize painting by finding a more authentic inspiration in the past. They saw medieval art as a model of probity and artistic freedom.

Back to basics: the Gothic Revival

This trend among artists to look backwards and rediscover the medieval

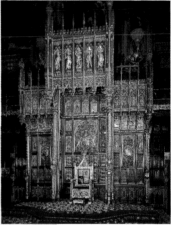

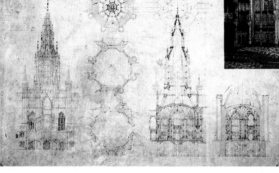

past affected both literature and architecture towards the mid-18th century. It gained ground very rapidly in England throughout the 19th century because of the climate of intense religious debate that responded to the pervasive spirit of doubt of the times. In architecture, the Gothic style that had marked the golden age of the great cathedrals was revived. It was brilliantly translated into contemporary forms by the architect Augustus Welby Northmore Pugin (1812–52).

Moreover, different trends coexisted within the Anglican Church, headed by the Queen. The High

According to Pugin, the architectural designs by Sir Charles Barry (1795–1860) for the new Houses of Parliament (below left, plan and elevation of the central tower) gave 'an Italian pattern to Gothic details'. Barry, a great perfectionist, wanted to control the decorative elements, which produced a fruitful, although sometimes difficult, collaboration with Pugin. They therefore did a great many sketches for the design of the royal throne. The final work, in painted and gilded carved oak (above), is a magnificent reinterpretation of 15th-century forms, which reflects both Barry's sense of monumental balance and Pugin's creative imagination.

Church was the most traditional of them. Some people hoped for a spiritual regeneration that was also expressed in medieval forms. This search for renewal was reflected very strongly in Oxford student circles and gave rise to the formation of groups such as the Oxford Movement with the famous sermon on national apostasy (1833) by the theologian John Keble (1792–1866) and Tractarianism (after Tract 90 published in 1841). Through the Cambridge Camden Society and in *The Ecclesiologist* (a journal concerned with the ideal church) Keble drew up architectural rules whose main supporters were Sir George Gilbert Scott (1811–78), William Butterfield (1814–1900) and George Edmund Street (1824–81).

These ideas governed the construction not only of many religious but also of civic buildings, the most famous of all being the new Palace of Westminster. The Fine Arts Commission headed by Prince Albert, Queen Victoria's consort, was responsible for the

A fter the Palace of Westminster buildings burnt down in 1834, they were rebuilt from 1840 to 1865 under the direction of Barry and Pugin. They represent the apotheosis of the Gothic Revival style. In addition to collaborating on the architecture, Pugin designed the furniture and interiors, displaying a rare virtuosity in his use of colour. The magnificent result can be seen below in Joseph Nash's painting of the opening of the House of Lords in 1851.

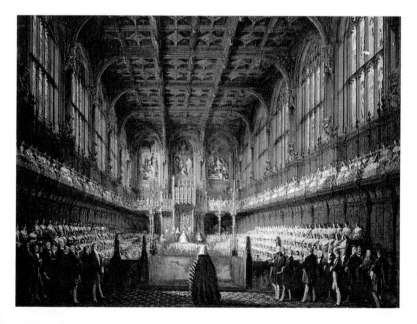

Italia and Germania (1828; left) by the Nazarene Johann Friedrich Overbeck is an allegorical celebration of the artistic union between the two countries. Stylistically, the painting reveals the new inspiration of early Italian art, the same source from which the Pre-Raphaelites later drew. The altarpiece below, acquired by Prince Albert, was exhibited in London in 1848. Queen Victoria bequeathed it to the National Gallery in 1863.

choice of artists commissioned to execute the murals of this parliament building. German by origin, Prince Albert openly chose contemporary German painting as his model. The result was a body of frescoes in a pre-Renaissance style that exalted English history and literature. Apart from the stylistic sources, it was this literary and nationalist character of the Gothic Revival movement that exerted such a strong influence on the early Pre-Raphaelites.

New models

In the 1830s and 1840s in England there was a growing interest in an art that did not conform to the rules of

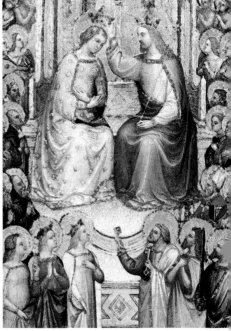

representation applied since the Renaissance and a taste for 'primitive' or medieval painting, perfectly exemplified by the collection Prince Albert had put together. The prince consort was in fact one of the cofounders, in 1848, of the Arundel Society whose aim was to make better known and to produce 'the severer and purer styles of earlier Art…and elevate the tone of our National School of Painting and Sculpture'.

A direct line can be established between Pre-Raphaelitism and European late Romanticism, reflected in particular by the close links with the Nazarenes, a German movement whose members included Johann Friedrich Overbeck (1789–1869), Peter von Cornelius (1783–1867), Julius Schnorr von Carolsfeld (1794–1872), Franz Pforr (1788–1812) and Wilhelm Schadow (1788–1862). The group formed the Brotherhood of St Luke in Vienna in 1809 and then moved to Rome, where they set up a kind of monastic community and modelled their work on medieval or pre-Renaissance painting, with the aim of purifying German religious art. Apart from its aesthetic theories, the religious aspect of that movement was a seminal influence on the formation of the Pre-Raphaelite Brotherhood, reflected also in the choice of name.

Two artists, William Dyce (1806–64) and Ford Madox Brown (1821–43) directly transmitted the ideas and styles of the Nazarenes to England. Both of them had in fact met Overbeck during their stays in

Although not a member of the Pre-Raphaelite Brotherhood, Ford Madox Brown was very close to the movement from its inception. In *Chaucer at the Court of King Edward III* (1845–51) he shows the birth of English poetry in the 14th century. The format and composition reflect the decorative style preferred by Brown, who also worked on the new Houses of Parliament.

Rome. Subsequently, Dyce became one of the main artists to support the Pre-Raphaelites. Rossetti was highly impressed by Ford Madox Brown's Early Christian style and in March 1848 he wrote Brown such an enthusiastic letter, asking to be allowed to study under him, that at first Brown took it as a joke.

'Go to nature': the influence of Ruskin

The Victorian art critic and theorist John Ruskin was an important influence on the Pre-Raphaelites. Born in 1819, the same year as Queen Victoria, Ruskin, who died in 1900, encapsulated the aesthetic aspirations of the time.

He came from a middle-class family and received a privileged and unusual education. His frequent travels with his parents throughout England and Europe fuelled his constant search to understand nature. He was trained not only in the sciences, learning biology, mineralogy and geology, but also in the arts, assiduously practising his drawing. He also developed a highly moral view of art and its social role. First and foremost came workmanship, which in his view reached its apogee in Gothic art, and this led him to consider how he could by this means revitalize art in the industrial age.

J. M. W. Turner (1775–1851) was, for him, a model in his approach to nature, not only as

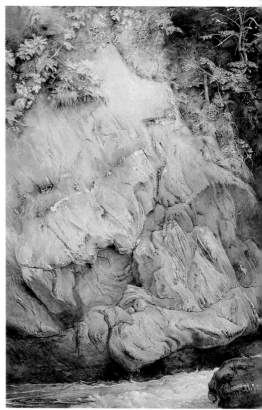

The *Study of Gneiss Rock at Glenfinlas* (1853; above), executed in Scotland, reflects Ruskin's fascination with geology. This watercolour may have been intended to help Millais paint the landscape setting for his portrait of Ruskin. The remarkable precision of the lines was influenced by the Pre-Raphaelites and by photography.

something to be observed minutely but also to be imbued with human passions. Ruskin's remarkable body of drawings reflects both this analytic approach and his poetic and mystical view of nature.

Although some of his work had already been published even before he went to Oxford, Ruskin's career really took off in 1843 with the publication of the first of the five volumes of *Modern Painters*. It is in the first volume that, inspired by Turner's works, though also anticipating the early Pre-Raphaelite theories, he exhorted young artists to 'go to Nature in all singleness of heart, and walk with her laboriously and trustingly, having no other thought but how best to penetrate her meaning, and remember her instruction, rejecting nothing, selecting nothing and scorning nothing'. The search for the direct and sincere representation of nature as the sole foundation

The response to Ruskin's work was considerable, both in England and on the continent, especially when he became successful after the 1860s. His most famous books, *Modern Painters* (1843–60), *The Seven Lamps of Architecture* (1849) and *The Stones of Venice* (1851–3) provide a real aesthetic and moral way of looking at art. Marcel Proust, a great Ruskin fan, interpreted his work as an affirmation of the absolute primacy of the artistic gesture. The pertinence and acuteness

MODERN PAINTERS:
THEIR SUPERIORITY
IN THE ART OF LANDSCAPE PAINTING

of any creative process once again harked back to the 'primitive' or Early Christian painters.

When he read the second volume of *Modern Painters* in 1847, Hunt discovered that he and Ruskin shared a common aspiration: 'He feels the power and responsibility of art more than any author I have ever read.' However, Ruskin's real links with the Pre-Raphaelites were

of Ruskin's writings are partly explained by the fact that he was not only a critic but was also a very talented draughtsman and watercolourist. He rarely portrayed the human figure, apart from a few self-portraits (left), preferring to concentrate on nature and architecture. 'I can only draw what I see,' he confessed.

not established until 1851 when, even before he had met a single member of the Brotherhood, he wrote two famous letters to *The Times* defending them in the face of vitriolic criticism.

The Pre-Raphaelite Brotherhood

This group of artists, all of whom had strong personalities, shared a common resolve to revitalize English painting and an enthusiasm for medieval art.

At the Royal Academy summer exhibition of 1848 Dante Gabriel Rossetti only found one painting to his liking, Hunt's *The Eve of St Agnes*. The two men became good friends and in August 1848 decided to share a studio in Cleveland Street near Regents Park

Dante G. Rossetti
P.R.B. 1849

in London. They also travelled together to Belgium and France, where they had their fill of medieval Flemish and German paintings. In 1849 they were impressed by Flandrin's 'frescoes' in the church of Saint-Germain-des-Prés in Paris.

Rossetti met Millais, who was already a friend of Hunt's and lived in the same part of London, through the Cyclographic Society. It was during their discussions that the idea of founding a society originated, probably suggested by Rossetti. The Brotherhood was officially formed in September. The precise origin of the name has never been definitively established. Some argue that the name arose in 1847 when Hunt and Millais publicly criticized Raphael's *Transfiguration* in front of their Royal Academy friends and a fellow student replied: 'Then you are Pre-Raphaelites.' Others attribute it to Rossetti, believing that the word brotherhood reflects the love of secrecy inherited from his family background. The decision to add the cryptic letters P. R. B., understood only by the few initiates, to their paintings gave rise

'We were all really like brothers, continually together and confiding to one another all experience bearing on questions of art and literature and many affecting us as individuals. We dropped using the term "Esquire" on letters and substituted "P. R. B." [the initials of the Pre-Raphaelite Brotherhood]....Those were the days of youth, and each man in the company, even if he did not project great things of his own, revelled in poetry or sunned himself in art.' W. M. Rossetti (ed.), *Dante Gabriel Rossetti*, 1895

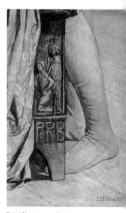

The initials 'P. R. B.' after Rossetti's signature (centre above) can also be seen engraved on the bench in Millais' painting *Isabella* (1848–9; detail above).

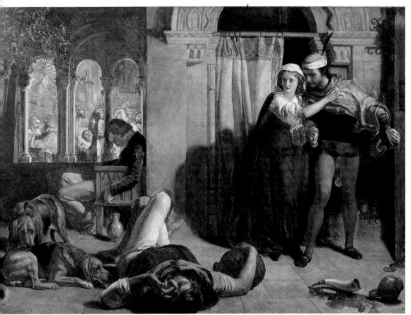

to some jokes when the initials were interpreted as 'Please Ring Bell' or 'Penis Rather Better'.

The extreme youth of the group – between nineteen and twenty-two years old – explains their capricious and immature behaviour, whether in their choice of name or their imprecise definition of the movement's aims. It is to W. M. Rossetti that we owe, in 1895, a retrospective declaration of intent, whose naivety no doubt faithfully reflects the spirit of the group: '1. To have genuine ideas to express. 2. To study Nature attentively, so as to know how to express them. 3. To sympathize with what is direct and serious and heartfelt in previous art, to the exclusion of what is conventional and self-parading and learned by rote.... 4. And, most indispensable of all, to produce thoroughly good pictures and statues.' Hunt summarized this statement as follows: 'In short, what we needed was a new and bolder English art that turned the minds of men to good reflection.'

Hunt submitted *The Eve of St Agnes* (1848; above) to the Royal Academy Schools while he was still a student there. To help him complete it on time for the exhibition, Millais painted some of the details. The scene, inspired by a poem by Keats, shows the flight of the two lovers, Madeline and Porphyro, after a drunken banquet.

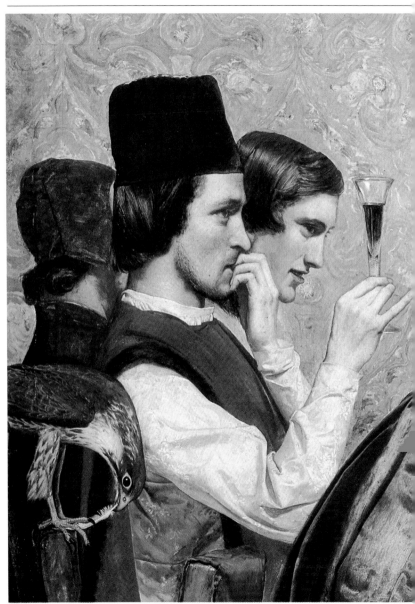

'Has the casual reader of art criticisms ever been puzzled by the occurrence of three mysterious letters as denoting a new-fashioned school or style in painting lately come into vogue? The hieroglyphics in question are "P. R. B." and they are the initials of the words "Pre-Raffaelite Brotherhood".'

Angus B. Reach
'Town Talk and Table Talk'
The Illustrated London News, 4 May 1850

CHAPTER 2

AVANT-GARDE ARCHAISM (1848–51)

In *Isabella* (opposite, detail), Millais adheres to the Pre-Raphaelite idea of revitalizing painting by following in the footsteps of the early Italians. Far from being a pastiche, the result looks very modern. In sculpture, Alexander Munro (1825–71) expresses a similar sensibility in his *Paolo and Francesca* (right).

The works by the Pre-Raphaelites were greeted with shock and incomprehension. The paradoxical choice of an archaizing style to reinvent contemporary painting was as surprising as the way they linked the search for naturalism to personal symbols with complex religious, literary and poetic connotations.

First exhibitions

The first official shows of paintings inscribed with the monogram P. R. B. – whose meaning had not been revealed to the public – took place in London in 1849. D. G. Rossetti exhibited *The Girlhood of Mary Virgin* at the Free Exhibition at Hyde Park Corner, also showing it at the Royal Academy with Millais' *Isabella* and Hunt's *Rienzi*.

The *Girlhood of Mary Virgin* was Rossetti's first large-scale painting. Drawing on medieval religious painting, he deployed a complex iconography that he explained in a sonnet inscribed on the frame; in the catalogue, a second sonnet was more specific about the picture's meaning:

Rossetti stressed that *The Girlhood of Mary Virgin* (1848–9; below) 'was a symbol of female excellence. The Virgin being taken as its highest type' and insisted that the subject was historically realistic. His models were his mother and sister, whose High Anglican views may have influenced the decoration and details of the painting. The stylistic tension between realism and archaism make its interpretation ambiguous.

'These are the symbols. On that cloth of red
I' the centre, is the Tri-point – perfect each
Except the second of its points, to teach
That Christ is not yet born.'

He also explained the floral symbols: the lily is the symbol of purity, the palm and the thorn prefigure the seven joys and sorrows of the Virgin. This close

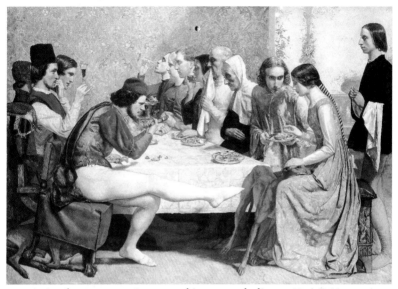

association between poetic text and image underlines Rossetti's ambition to be both poet and painter.

Isabella was the first picture Millais painted according to Pre-Raphaelite principles. He drew his inspiration from a tale by Boccaccio reinterpreted in Keats' poem 'Isabella; or The Pot of Basil'. Once again, the painting was accompanied by an extract from the poem:

'Fair Isabel, poor simple Isabel!
Lorenzo, a young palmer in Love's eye!
They could not in the self-same mansion dwell
Without some stir of heart, some malady;
They could not sit at meals but feel how well
It soothed each to be the other by....'

Isabella (above and drawing, left) reveals the Pre-Raphaelite predilection for portraying their own intimate world: F. G. Stephens is the model for one of Isabella's brothers, on the left, holding a glass of wine; Walter Deverell is shown sitting to his left; and Jack Harris to his right, kicking the dog; the man at the back drinking is D. G. Rossetti; William Hugh Fenn, whose son was a friend of Millais', is the man peeling an apple; the painter's father is the man wiping his mouth; Lorenzo is probably a portrait of W. M. Rossetti; and the model for Isabella is the wife of Millais' half-brother.

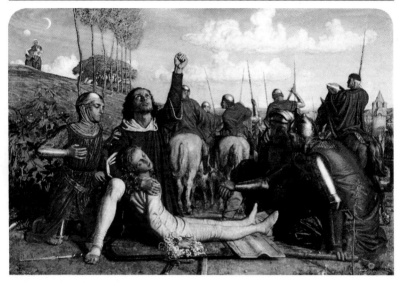

Millais chose the moment during the meal when Isabella's brothers become aware of the love between her and Lorenzo. They then murder the young pretender and lie to their sister to conceal their deed. After Lorenzo's ghost appears to her to reveal the truth, Isabella exhumes the body and cuts off the head, which she keeps in a pot of basil. This sumptuous work, influenced by medieval painting, was one of the first masterpieces of the movement.

In *Rienzi Vowing to Obtain Justice...* Hunt drew on a historical novel by the Victorian writer Bulwer-Lytton, *Rienzi, the Last of the Tribunes* (a second edition had been published in 1848), which tells of the life of a 16th-century republican, Cola di Rienzi, who headed a popular revolution to overthrow the Roman nobility. The scene depicted by Hunt is taken from the first chapter, just after Adrian, the hero's young brother, is killed. In fact, the painting reflects the political events of 1848, as Hunt explained in 1905: 'Like most young men, I was stirred by the spirit of freedom of the passing revolutionary time.

In his pamphlet *Pre-Raphaelitism*, published in 1851, Ruskin emphasized that Hunt painted the landscape elements of *Rienzi...* (1848–9; above) out of doors. However, Hunt is also drawing on religious iconography here; the poses of the protagonists, especially the groups of the two brothers and the two soldiers, are in fact reminiscent of the traditional depiction of the lamentation of Christ, accentuating the idea of the hero as redeemer and saviour.

The appeal to Heaven against the tyranny exercised over the poor and helpless seemed well fitted for pictorial treatment.' It was probably one of the first times a Pre-Raphaelite artist had put into words his desire to treat modern subjects, even though this painting is set against a medieval background. Yet it also reflects Hunt's aesthetic ambitions, stimulated by his reading of Ruskin, who emphasized the importance of 'an out-of-door picture…painting the whole out of doors, direct on the canvas itself, with every detail I can see, and with the sunlight brightness of the day itself'. The painter's friends posed as the main figures: Rossetti for Rienzi, Millais then William Michael Rossetti for Adrian. The Pre-Raphaelite rebellion is embodied by three of its principal protagonists in a strongly revolutionary context.

The Germ

The three paintings were sold and were not overly criticized: so the official debut of the Pre-Raphaelites went off fairly well. The confidence the Brotherhood

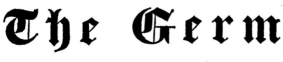

felt led to Rossetti's proposal of publishing a monthly magazine to reflect the movement's literary and poetic theories. *The Germ*, as it was called, had a short life and only four issues appeared between January and April 1850. Nevertheless, this magazine remains the first publication by an avant-garde artistic movement. Rossetti had broken with the English tradition of a text/image association conceived in a purely illustrative form. The texts included poems, news and theoretical writings on art and criticism.

For the Pre-Raphaelites, 1850 was a year of change. Thanks to *The Germ*, the Brotherhood became better

Although the authors of the first issue of *The Germ* magazine (centre, title page) remained anonymous, the contributions to the first four numbers were signed by the Rossetti brothers and their sister Christina, by Woolner, Stephens and also by the young, and then unknown, poet Coventry Patmore (1823–96), by Ford Madox Brown, William Bell Scott (1811–90),

Walter Howell Deverell and William Cave Thomas.

The Germ was retitled *Art and Poetry* for the fourth issue. It aimed 'to obtain the thoughts of Artists, upon Nature as evolved in Art, in another language besides their own proper one…to enunciate the principles of those who, in the spirit of Art, enforce a rigid adherence to the simplicity of Nature either in Art or Poetry'.

known among the public, and as a result the secrecy in which its members wanted to shroud themselves began to be eroded. An article in *The Illustrated London News* of 4 May 1850 revealed the meaning of the three enigmatic letters.

Religious themes cause a furore

This early success was short-lived. The furore against the Pre-Raphaelites began when Rossetti showed *Ecce Ancilla Domini!*, an Annunciation, at the National Institution in April 1850. His brother summarized his approach to the representation of religious themes by describing this painting as a 'vehicle for representing ideas'. It was intended as part of a diptych, the second panel of which would have shown the Virgin's death, though it was never executed. Like *The Girlhood of Mary Virgin*, it is strongly inspired by the medieval paintings Rossetti had seen on his recent visit to Flanders and Italy. However, the critics also found this painting disturbing because it was too innovative and daring.

The iconography is curious, with the Virgin shown semi-prostrate. The use of a most untraditional palette virtually reduced to primary colours (white is dominant, whereas the Virgin is normally associated with blue) unleashed the fury of the

Ecce Ancilla Domini! (below) was severely criticized by the press. In 1850 the *Athenaeum* condemned it as 'a work evidently thrust by the artist into the eye of the spectator more with the presumption of a teacher than in the modesty of a hopeful and true aspiration after excellence'.

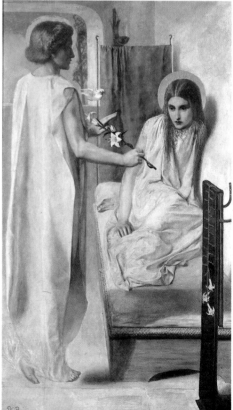

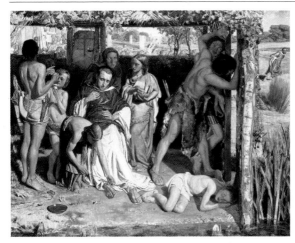

Through the intermediary of Millais, Hunt sold *A Converted British Family* (1850; left) to Thomas Combe, who became a major collector of Pre-Raphaelite art.

The sculptor Thomas Woolner, shown here in a caricature by D. G. Rossetti (below), was one of the seven founder members of the Brotherhood and a believer, like them, in the revival of an inspiration common to all the arts. In sculpture, as in painting, the Pre-Raphaelites took a realistic approach to portraiture but chose a more idealized style for literary and mythological subjects.

critics. The atmosphere is unreal but the almost anguished expression Rossetti gives to the Virgin is very human (Christina was his model). The painting was an innovative rendering of the theme of the Annunciation. One critic, however, described the painter as 'the high priest of this retrograde school'.

Yet it was at the Royal Academy exhibition of 1850 that the Pre-Raphaelites had to face virulent criticism. Hunt showed *A Converted British Family Sheltering a Christian Missionary from the Persecution of the Druids.* In response to the subject proposed in 1849 for the Royal Academy Gold Medal contest on the theme, 'An Act of Mercy', Hunt once again chose as his theme oppression, shown here from the angle of religious persecution. He painted the landscape in the open and the figures in his studio, but under natural lighting (W. M. Rossetti posed as the missionary). Through this evocation of a

1st-century scene, he in a sense transposed the Passion of Christ. The painting is riddled with symbols that include references to the Eucharist (the grapes about to be squeezed) and the baptism (the child holding the cup of water, the river in the foreground). In 1851 Hunt explained that the nature he had described so accurately was here a symbol of 'the civilizing effect' of Christianity.

A 'revolting' picture

The painting that gave rise to the most ferocious attacks by the critics was Millais' *Christ in the House of His Parents,* which he also showed at the Royal Academy. Once again the subject can probably be traced back to his interest in the Oxford Movement, since Hunt tells us that Millais thought of it after listening to a sermon by one of the Oxford theologians. Stylistically it owes much to Rossetti. At the time the two painters were executing a number of sketches that reflected a similar approach and to which the studies for this painting can be related. The realistic treatment of such sophisticated subject matter seemed deeply shocking to many at the time. *The Times* wrote: 'Mr Millais' principal picture is, to speak plainly, revolting. The attempt to associate the holy family with the meanest details of a carpenter's shop, with no conceivable omission of misery, dirt, or even disease, all finished with the same loathsome minuteness, is disgusting.' After initially

Millais applied Pre-Raphaelite principles when he painted *Christ in the House of His Parents* in a mixture of realism and symbolism. Christ is shown in the centre with the Virgin, with, to the right, Joseph and John the Baptist, who is carrying a bowl of water that prefigures the baptism, and, on the left, the Virgin's mother St Anne and one of Joseph's assistants. Left and opposite: preliminary drawings.

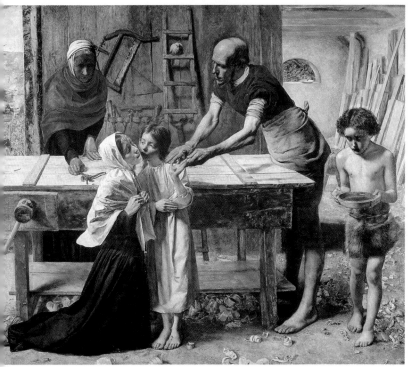

encountering a certain amount of goodwill, even indifference, the Brotherhood now found its secret regarded as pretentious impertinence and the realism with which it intended to renew painting as verging on the blasphemous. The most famous diatribe came not from traditional critics but from a renowned writer, which of course gave it more publicity. In his journal *Household Words* (15 June 1850), Charles Dickens castigated Millais' painting as being 'the lowest depths of what is mean, odious, repulsive and revolting'. The picture created such a stir that Queen Victoria had it taken down and shown to her in private.

The backdrop of the studio with its planks of wood and nails, like the wound on the hand of the young Jesus dripping blood on to his foot, herald the death of Christ. The triangular set-square on the wall above Christ's head symbolizes the Trinity, while the flock of sheep in the distance represents the faithful. In his concern for realism, Millais based the interior on a real shop and Joseph's body on a real carpenter.

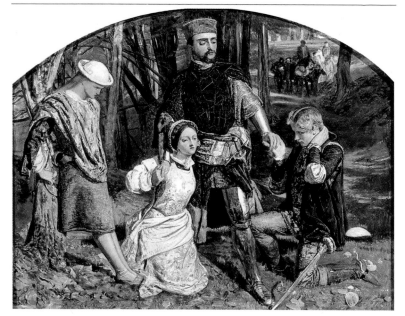

Faced with such public pressure and hostility, the Brotherhood had to change its approach. Rossetti's decision not to exhibit in public again dealt the first blow to the spirit of the group, as Millais and Hunt were perfectly aware. Yet the Pre-Raphaelites also acquired new members, such as Charles Allston Collins (1828–73), Arthur Hughes (1832–1915) and Walter Deverell (1827–54).

In 1851 Hunt exhibited his first painting, *Valentine Rescuing Sylvia from Proteus* (above), inspired by a Shakespeare play, *The Two Gentlemen of Verona*. Most of the landscape was painted in the open air.

'A school of art nobler than the world has seen for three hundred years'

The same critical furore greeted the 1851 Royal Academy exhibition, where the Pre-Raphaelites showed the following works: *Mariana, The Woodman's Daughter*, and *The Return of the Dove to the Ark* by Millais; *Valentine Rescuing Sylvia from Proteus* by Hunt; and *Convent Thoughts* by Collins. However, this time Ruskin, whom Dyce had introduced to the Pre-Raphaelites, wrote two letters to *The Times* (14 and 30 May 1851), followed by the publication of a pamphlet (*Pre-Raphaelitism*) in which he defended the young painters:

'They may, as they gain experience, lay in our England the foundations of a school of art nobler than the world has seen for three hundred years.'

What is particularly striking in Collins' *Convent Thoughts* is the luminosity of the painting, its intense, harsh colours, obtained by a special process that David Wilkie (1785–1841) and William Mulready

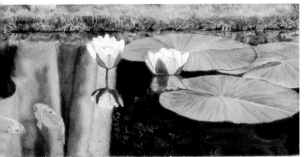

Collins was a close friend of Millais' but never a member of the Brotherhood. However, his *Convent Thoughts* (1850–1; above) was strongly attacked by the press on the grounds that it exacerbated all the faults of Pre-Raphaelitism in its choice of a subject with such strong High Church connotations and in its radical treatment of colour. Ruskin defended this 'invaluable' picture in one of his letters to *The Times*. Opposite: detailed view of the lily pond and goldfish.

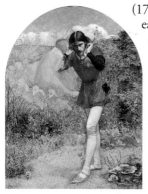

(1786–1863) had used earlier, but in the context of a studio painting. He painted the colours on a wet white ground. This technique can be explained in part by the desire to produce an effect reminiscent of Italian frescoes, although the Pre-Raphaelites were not very familiar with the principles. Their aim was to reassert the value of colour, an idea Ruskin also encouraged, in contrast to academic doctrine.

The beginnings of recognition: literary subjects

After the introduction of religious themes met a storm of criticism, the Pre-Raphaelites turned towards literary subjects. By placing themselves in a cultural tradition, they managed to achieve recognition. Their choice of authors reflected the changing taste, for they often turned to John Keats and to contemporary poets such as Alfred, Lord Tennyson, and Coventry Patmore. Shakespeare, so greatly admired by the Romantic generation, remained a major inspiration. For *Ferdinand Lured by Ariel*, Millais drew on *The Tempest*, producing one of the most surprising examples of the fairy paintings so popular in Victorian times. Shakespeare was also the inspiration for Deverell's *Twelfth Night* and Millais' *Mariana* was accompanied by an extract from Tennyson inspired by *Measure for Measure*.

Mariana's endless wait for her fiancé Angelo – her inheritance was lost in a shipwreck – becomes a sumptuous variation on the theme of almost voluptuous abandonment to, if not desire for, death which recalls the motto inscribed on the stained glass *In coelo quies* (In Heaven there is rest). The subtle

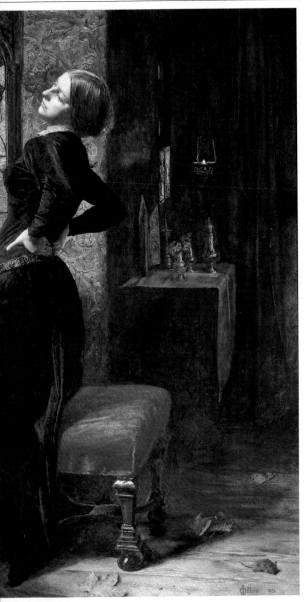

With his *Ferdinand Lured by Ariel* (1849–59; opposite) Millais produced a daring collage between a landscape painted out of doors with great precision and a totally fantastic world that bursts into this framework. The sprite Ariel, carried by curious bat-like creatures, teases Ferdinand by announcing that his father has drowned in the shipwreck that has landed them on the shores of Ariel's master, Prospero.

Millais displays his artistry in the many medieval references and the wealth of detail of his *Mariana* (1850–1; left). In a provocative pose, the young woman, who had spent five years in a moated grange, stretches her back in boredom. Most of the picture was painted in Oxford and was inspired by the stained glass in the Chapel of Merton College, although Millais modified it slightly. The garden glimpsed through the window is said to be that of Thomas Combe, with whom Millais was staying. The small mouse in the lower right corner, which draws attention to the signature, is an open allusion to Tennyson's poem of the same name.

fusion of sensuality and spirituality that Millais achieved here did not escape Ruskin: 'On the whole the perfectest of his works, and the representative picture of that generation – was no Annunciate Maria bowing herself; but only a Newsless Mariana stretching herself.'

Hunt's *The Hireling Shepherd* (1851–2; below) is a mixture of the minute and naturalist rendering of the English countryside and

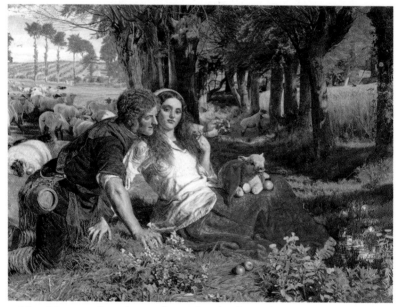

Like *Mariana*, the subject of Hunt's *Claudio and Isabella* is drawn from *Measure for Measure*. The moral rift between Claudio and his sister Isabella gave Hunt an opportunity to tackle the question of prostitution, which was particularly significant in Victorian society.

Hunt's *The Hireling Shepherd* was inspired by Edgar's song in *King Lear* (Act III, scene vi). Hunt summarized the scene as follows: '[It] represents a Shepherd who is neglecting his real duty of guarding the sheep: instead of using his voice in truthfully performing his duty he is using his *minnikin mouth* in some idle way. He was thus the

religious symbolism. In its close observation of nature, this work is an almost perfect application of Ruskin's theories. Moreover, far from simply illustrating Shakespeare's text, the painting is conceived as a symbolic interpretation of the contemporary English religious controversies, which Hunt regarded as being totally sterile.

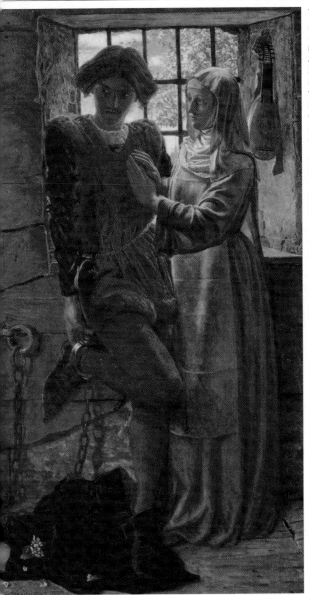

Hunt showed *Claudio and Isabella* (1850–3; left) at the 1853 Royal Academy exhibition. In it he explores the moral symbolism that was his hallmark and in particular the subject of prostitution, which he tackled a few years later in *The Awakening Conscience* (1853–4). Claudio is seen imploring his sister to give herself to their enemy Angelo to save him from certain death. Here Claudio is shown as a figure of evil, in contrast to Isabella who personifies goodness. Hunt executed a great many sketches and worked constantly on the pose of the two figures, eventually deciding to show Isabella upright and Claudio in a contorted pose that suggests his evil and cowardly spirit.

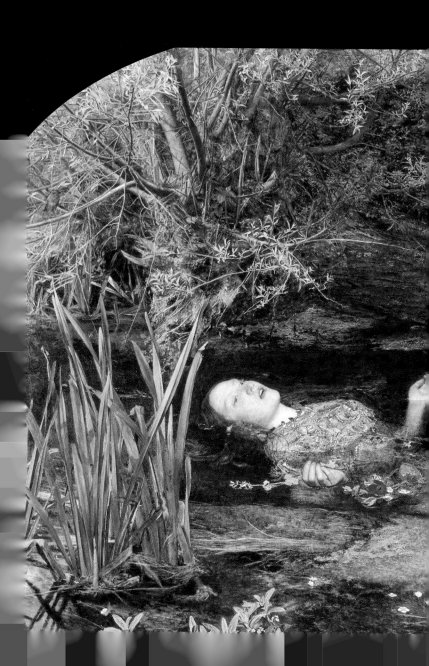

type of muddle-headed pastors, who, instead of performing their services to their flock – which is in constant peril – discuss vain questions of no value to any human soul.'

Millais' *Ophelia* was undoubtedly a high point of these early years. Shown, like *The Hireling Shepherd*, at the 1852 Royal Academy exhibition, it was inspired by Act IV, scene vii of *Hamlet*. In it, Queen Gertrude describes how Ophelia went mad and drowned herself in the river after learning that her lover had killed her father.

During the summer of 1851 Millais painted a landscape from nature on the banks of the Hogsmill River in Surrey. At the time he was staying in Ewell, Surrey, with Hunt, who painted *The Hireling Shepherd* in the same spot (the two paintings were hung side by side at the Royal Academy). He painted the figure of Ophelia at a later stage, in London in the winter. The model was Elizabeth Siddal, whom Walter Deverell had discovered in 1849, when she was twenty, working as a shop assistant at a milliner's in Covent Garden. In order to paint the picture, Millais asked Elizabeth to lie in his studio in a tepid bath of water heated by lamps positioned underneath it. According to William Michael Rossetti, once, when the lamps went out, the model caught a severe cold and her father threatened to take Millais to court until he agreed to pay the doctor's bills.

This painting reflects the two approaches to painting characteristic of the Pre-Raphaelites. Naturalist in its meticulous depiction of the flora, the painting is also imbued with a complex

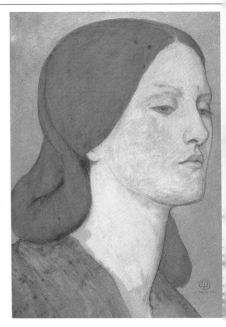

Elizabeth Siddal became one of the Pre-Raphaelites' favourite models. Above: her portrait (1850–65) by Rossetti. Opposite above: Millais' preliminary drawing for *Ophelia*.

Millais described the genesis of *Ophelia* (pages 40–1 and detail, below): 'I sit tailor-fashion under an umbrella throwing a shadow scarcely larger than a halfpenny for eleven hours, with a child's mug within reach to satisfy my thirst…I am threatened with a notice to appear before a magistrate for trespassing in a field and destroying the hay; likewise by the admission of a bull in the same field after the said hay be cut; am also in danger of being blown by the wind into the water, and becoming intimate with the feelings of Ophelia when that Lady sank to muddy death, together with the (less likely) total disappearance, through the voracity of the flies. There are two swans who not a little add to my misery by persisting in watching me from the exact spot I wish to paint, occasionally destroying every water-weed within their reach.'

J. G. Millais, *The Life and Letters of Sir John Everett Millais*, 1899

symbolism that contains multiple allusions to Ophelia's fate, as revealed in the choice of plants and flowers.

Millais' painting, which immediately found critical and popular acclaim at the 1852 Royal Academy exhibition, helped to make the movement better known. Curiously, Ruskin did not at first approve of *Ophelia*, although he later described it as 'the loveliest English landscape, haunted by sorrow'.

Significantly, Millais broke with the traditional and classical representation of Ophelia as a woman who is both tragic and seductive, as in its treatment by, for example, Delacroix. Millais invested his subject with a curious hypnotic and morbid air, which influenced turn-of-the-century painting and literature.

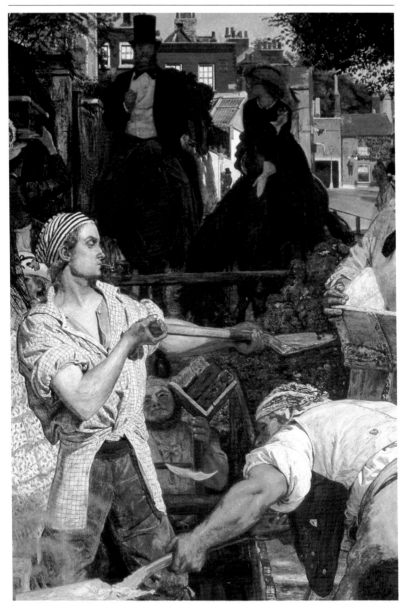

The Pre-Raphaelites wanted to represent modern life realistically, whether they approved or disapproved of it. Yet the styles and the moral and religious overtones of their works reflect their very different personalities and approaches.

CHAPTER 3
INDIVIDUAL DESTINIES
(1852–6)

A critic in *The Saturday Review* of 25 March 1865 summed up Ford Madox Brown's *Work* (detail, opposite) as 'simply the most truthfully pathetic, and yet the least sentimental, rendering of the dominant aspect of English life that any of our painters has given us'.

R ight: *Portrait of Ford Madox Brown* by Millais (1853).

'We miss the poetry of the things about us'

The new spirit in painting brought with it new subject matter: contemporary themes. At first it was more a question of theory, which was set out as follows in the pages of *The Germ:* 'We miss the poetry of the things about us, our railways, factories, mines, roaring cities, steam vessels, and the endless novelties and wonders produced every day' (F. G. Stephens, May 1850 issue). Victorian narrative painting had already tried to depict this world but the Pre-Raphaelites adopted a more critical approach, drawing on the concept of the Modern Moral

The setting for *Work* (begun 1852; below) is Heath Street in Hampstead, painted under 'a hot July sunlight...because it seems peculiarly fitted to display work in all its severity and not from any predilection for this kind of light over any other' (Hunt, 1865 catalogue).

Subject as defined by the painter William Hogarth (1697–1764).

The first ambitious pictorial translation of this concern is by Ford Madox Brown, an artist on the margins of the movement. The subject of *Work*, which he began in 1852 and did not complete until the mid-1860s, owes much to the ideas of the Scottish essayist and historian Thomas Carlyle (1795–1881), particularly his *Past and Present* (1843), and of Thomas E. Plint (1823–61) of Leeds, a speculator and collector of Pre-Raphaelite paintings, who commissioned the picture and asked, in 1856, for more specific moral and religious overtones, something very apparent in Brown's work in any case. This celebration of the moral value of work in a sense reflects the whole spectrum of Victorian society, from intellectuals to manual labourers.

On a rather similar though less dogmatic note, Brown described *The Last of England* (1852–5) as a picture [that] is 'in the strictest sense historical. It treats of the great emigration movement which attained its culminating point in 1852'. This work was inspired by Thomas Woolner's departure for Australia to seek his fortune during the gold rush of 1852.

Brown, who was also in financial difficulties, had

The philosopher and historian Thomas Carlyle (on the left) and the Reverend F. D. Maurice (on the right) posed for this preliminary study by Brown (above). In the painting (left), a poster for the Working Men's College founded by Maurice hangs on the left wall.

•Seeing and studying daily as I did the British excavator…in the full swing of his activity…it appeared to me that he was at least as worthy of the powers of an English painter as the fisherman of the Adriatic, the peasant of the Campania and the Neapolitan lazzarone.• Ford Madox Brown, 1865 catalogue

briefly considered emigrating himself, to India. In an attempt to translate a family tragedy into contemporary history, he shows himself and his wife Emma, accompanied by their two children, as a pair of resigned and melancholy emigrants. The unusual oval form of the painting concentrates the viewer's eye on the couple, emphasizing their moral isolation.

Painting as social criticism

Henry Wallis (1830–1916) was another artist who was intermittently associated with the Pre-Raphaelites. In terms of style and subject matter, *The Stonebreaker* and *Chatterton* are very close. In *The Stonebreaker* Wallis is referring back to Carlyle, for the painting was exhibited at the 1858 Royal Academy exhibition with a quotation from Chapter 4 of *Sartor Resartus*, in which Carlyle explains his

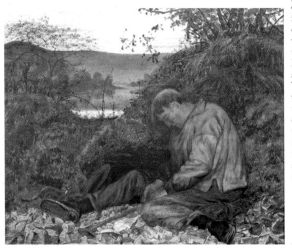

•To insure the peculiar look of *light all round,* which objects have on a dull day at sea, it was painted for the most part in the open air on dull days, and when the flesh was being painted, on cold days. Absolutely without any regard to the art of any period, I have tried to render this scene as it would appear. The minuteness of detail which would be visible under such conditions of broad daylight, I have thought it necessary to imitate, as bringing the pathos of the subject more home to the beholder.•
Ford Madox Brown on *The Last of England* (above) in *The Exhibition of 'Work' and Other Paintings,* 1865

admiration for two types of worker: the manual worker or 'toilworn craftsman', and the 'inspired thinker'. It is that second symbolic type that Wallis depicts in *Chatterton*, a painting that immortalized the penniless young poet who killed himself at the age of eighteen; it reflects a Romantic sensibility and was a huge success at the 1856 Royal Academy. The sitter was the novelist and poet George Meredith, whose wife fell in love with Wallis and eloped to France with him.

In his concern for authenticity and close attention to the smallest detail, Henry Wallis drew inspiration from contemporary descriptions of the death of Chatterton who, penniless and in despair, committed suicide in his youth by swallowing arsenic (1855–6; below).

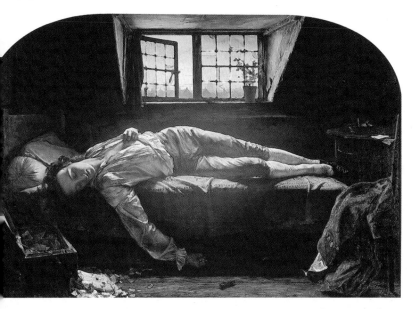

Both works evoke death: the poet's death suggests society's incomprehension, while the stonebreaker's death is the result of the cruel rules of society. *The Stonebreaker* is a condemnation of the Poor Law, under which the poor were employed to break stones in order to repair the roads. In return they received board and lodging. The drastic treatment of the painting was a strong and poignant break with the accepted image of the benefits of work.

The subject of *The Stonebreaker* (1858; opposite bottom) had been treated by Gustave Courbet in 1849 and it no doubt influenced Wallis, who did part of his training at the Ecole des Beaux-Arts in Paris.

An experiment: the Working Men's College

Some of the Pre-Raphaelite artists decided to penetrate a little further into the reality of contemporary life by taking part in a new educational experiment. The social concern with improving the level of artistic education and the very Ruskinian idea of encouraging a contemporary English art school lay at the origin of the Working Men's College which the Christian Socialist F. D. Maurice (1805–72) founded in 1854. The College, in Great Ormond Street in Bloomsbury, taught every variety of arts and crafts (there were jewellers, furniture-makers, lithographers, engravers and bookbinders). Maurice's venture reflected his own brand of Christianity, but he also allowed some innovative spirits who taught there for nothing to disseminate their ideas.

Ruskin taught drawing, preaching ideas that were fairly revolutionary for the time, based on the recovery of 'the innocence of the eye' and the exact and faithful reproduction of nature.

These principles, which he also set out in his book *The Elements of Drawing* (1859), had been put into practice by the Pre-Raphaelites from the outset. It was not surprising that Ruskin wanted some of them to teach at the college.

Although he was much older, William Dyce was very close to the Pre-Raphaelites, both influencing and learning from them. At an early date he became interested in landscape

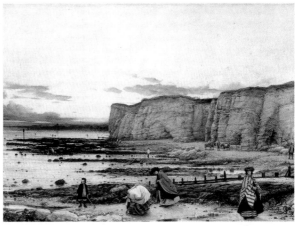

The choice of Rossetti to teach figure and watercolour painting was unusual, however, given that his rather capricious personality did not fit in very well with the rhetorical and technical rigour of Ruskin's classes. Nevertheless, Rossetti's genuine passion for art made up for his deficiencies. Indeed, several young artists, including Edward Burne-Jones, found the classes a real source of inspiration. Rossetti gave up teaching in 1858, and was replaced by Ford Madox Brown.

painting in the open air. His *Pegwell Bay, Kent: A Recollection of October 5th, 1858* (1858; above) places a group of figures against the forces of nature that they fail to notice – Donati's comet in the sky and the geology of the rocks. More prosaically, John Inchbold (1830–88) in *A Study, in March 1855* (left) transcribes every minute detail of the coppice. The painting was exhibited at the Royal Academy in 1855, accompanied by a few elegiac lines from Wordsworth.

A worthy subject of study: the fallen woman

The Victorian conscience, especially as expressed in literature and painting, constantly focused on female weakness in all its forms (adultery, illegitimate children, prostitution). The Victorians took a close interest in, and a generally compassionate approach to, the subject, believing that such situations had resulted from the development of urban industrial society, which had lost for ever the innocence of rural life – perceived as a real Arcadia – and which caused women to face all sorts of temptations.

Millais' *The Woodman's Daughter* (1850–1), inspired by a poem of the same title by Coventry Patmore, concerns a woodman's daughter who goes mad after drowning her illegitimate child. It started a series of Pre-Raphaelite works about modern life and the fate of lost souls.

Rossetti's *Found* is the only contemporary theme ever treated by that painter: 'A drover has left his cart…and has run a little way after a girl who has passed him…and she, recognizing him, has sunk under shame upon her knees' (letter to Hunt, 30 January 1855). He set the scene in a rather seedy part of London, Blackfriars Bridge, and it was probably inspired by Henry Mayhew's book *London Labour and the London Poor* (1851–62) and the many contemporary novels on

There are many possible sources or parallels to Rossetti's *Found* (1854–81; below), since prostitution was the subject of intense public and literary debate. Charles Dickens, who included the character of a prostitute in his book *David Copperfield,* had founded a home for repentant prostitutes.

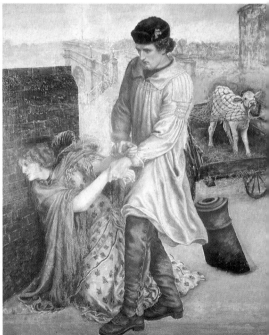

similar themes. His model was Fanny Cornforth, a prostitute who became his mistress. He left drawings and two unfinished oils of her.

Brown's *Take Your Son, Sir!* is another unfinished and ambiguous painting. The models are the painter's wife Emma and their second child Arthur. This young woman holding out her baby to his father is a strange kind of Madonna. The spectator is virtually forced into the place of the father, whose grimacing features are glimpsed in the convex reflection in the mirror. This complex composition is an allusion to the mirror reflection in Van Eyck's *The Marriage of Giovanni Arnolfini and Giovanna Cenami* (1434) in the National Gallery, one of the paintings most admired by the Pre-Raphaelites. Is Brown's painting a celebration of marriage and the family or a condemnation of illegitimacy? Could the presence of Brown's wife and child be explained by the painter's 'irregular' situation on the birth of his first child? The picture could be interpreted as a gesture of accusation, facing the father/spectator with his responsibilities. The feeling of unease that emanates from the painting – later found in Symbolist works – and its incompleteness make it one of the most disturbing visions of motherhood in 19th-century painting.

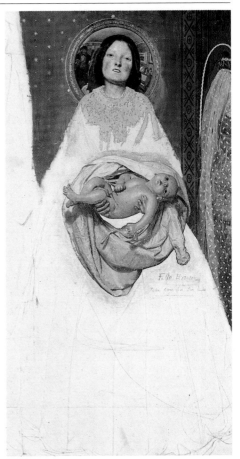

Brown's *Take Your Son, Sir!* (1851) may have been influenced by the heated debate prior to the passing of the 1857 law that for the first time authorized women to file for divorce on the grounds of desertion or cruelty.

Hunt or the possibility of redemption

William Holman Hunt introduced a more optimistic note into these visions of modern life. For *The Awakening Conscience*, which he first showed at the Royal Academy in 1854, he drew his inspiration from a passage from Proverbs: 'As he that taketh away a garment in cold weather…so is he that singeth songs to an heavy heart', which he inscribed on the picture frame. For, he said, 'these words expressing the unintended stirring up of the deeps of pure affection by the idle sing-song of an empty mind, led me to show how the companion of the girl's fall might himself be the unconscious utterer of a divine message'. Hunt's model was his mistress Annie Miller and to show the irregular nature of their relationship, he openly portrayed the girl without a wedding ring and took great care with the decoration and furniture, whose 'fatal newness', according to Ruskin, is also meant to suggest that this is a kept woman. The painting is also full of revealing symbols, like the cat that has failed to catch its prey, the music score on the floor to Tennyson's 'Tears, Idle Tears', a poem about lost innocence, and the fact that all that can be seen of nature is its reflection in the mirror.

In his search for a setting appropriate to the subject of *The Awakening Conscience* (1853–4; below), Hunt rented a room in a house in St John's Wood which, according to his daughter, was a *maison de convenance* or house of ill-repute. This painting, on the theme of the fallen woman, was attacked by the critics as sensational.

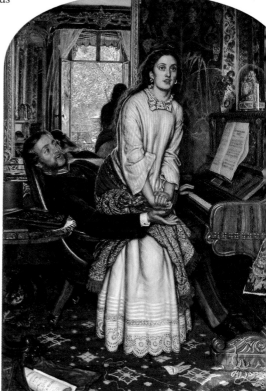

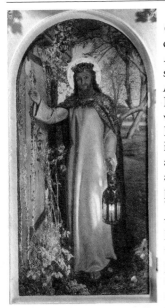

The Awakening Conscience, a counterpart to *The Light of the World*, shown at the Royal Academy in 1854, was Hunt's first religious work. A passage from Revelation (3.20) was inscribed on the frame and reprinted in the accompanying pamphlet: to show 'how the still small voice speaks to a human soul in the turmoil of life'. This picture was painted out of doors, at night, a technical challenge to which Millais managed to rise. At the time he was staying in Surrey with Hunt and he records in his diary: 'This evening walked out in the orchard (beautiful moonlight night, but fearfully cold) with a lantern for Hunt to see effect…which he intends doing by moonlight.' In his desire to confront nature directly, Hunt always remained faithful to Pre-Raphaelite principles, but at the time the painting was not understood and was poorly received, though it was bought by the collector Thomas Combe (1797–1872). Very successful sales of engravings and photographs of it at the end of the century confirmed the popularity of the painting, the most famous of English religious pictures.

Hunt completed *The Light of the World* (1851–3; left) in his studio, where he rigged up an elaborate arrangement of screens and curtains to reconstruct artificially the effects of light he wanted, both day and night. W. B. Scott criticized him as follows: 'He was determined to carry out this accurate method of representation even when the subject was so removed from the realities of life.' Hunt took great trouble with the design of Christ's lantern and in his search for perfection even constructed a model of it (below, preliminary drawing). In his view, 'the diversity of designs of the openings of the lantern' were 'essential to the spiritual interpretation of the subject'; the reference here is probably to the seven churches in Revelation.

The mystical search for truth

Hunt, ironically called the 'high priest' of the Pre-Raphaelite movement, did not draw a distinction between his religious faith and the practice of his art. At first *Our English Coasts*, a commissioned work

painted at Covehurst Bay near Hastings, was interpreted as a satire on the defenceless England against hypothetical French invasion. However, with the second title he gave this work, *Strayed Sheep*, the religious symbolism became more evident, especially with the reference to Isaiah 53: 'All we like sheep have gone astray.' Ruskin waxed lyrical about the effects of light on colour.

Hunt, who had become increasingly interested in religious painting, left England in 1854 on a two-year journey to Egypt and Palestine, despite the disapproval of his friends Rossetti, Millais and Ruskin. It was during his studies of traditional Hebraic rituals for *The Finding of the Saviour in the Temple* that he came upon the theme for *The Scapegoat*. The subject, drawn from Leviticus, describes the Day of Atonement ritual, when one of two goats – symbols of the Jews' annual expiation of their sins – is sent off into the wilderness to make atonement. The setting Hunt chose was Kharbet-Esdoum by the Black Sea, the supposed site of

By the Black Sea, in the middle of a hostile wilderness threatened by robbers, Hunt set to work on *The Scapegoat* (1856): 'I continued placidly conveying my paint from palette to canvas, steadying my touch by resting the hand on my double-barrelled gun…as steadily in my studio

Sodom. This work still remains one of the most disturbing of all Pre-Raphaelite paintings, an extreme point in religious painting.

'Now the whole Round Table is dissolved'

In 1850, when Hunt took Rossetti to Sevenoaks in Kent to paint landscapes, the different approaches of the two artists became very clear. Aware that he was unable to restrict himself to the minute observation of nature, Rossetti very soon gave up all thought of painting out of doors: 'The fact is, between you and

*O*ur English Coasts (1852; below) was sent in 1855 to the Exposition Universelle in Paris, where it was admired by Delacroix. Hunt changed its title at that time to *Strayed Sheep*, probably because he had also submitted *The Light of the World* and wanted to stress the religious symbolism common to both works.

me, that the leaves on the trees I have to paint here, appear red, yellow etc. to my eyes; and as of course I know them on that account to be really of a vivid green, it seems rather annoying that I cannot do them so: my subject shrieking aloud for Spring' (25 October 1850).

The fragile cohesion of the early Pre-Raphaelite movement began to dissolve as the painters' different characters became more apparent. When Thomas Woolner emigrated to Australia in 1852 and Hunt left for the Holy Land in 1854, the group began to break up. In November 1853 Rossetti summarized the general view in a letter to his sister Christina, referring to Millais' election to the Royal Academy:

'Millais, I just hear, was last night elected associate, so now the whole Round Table is dissolved.'

For more strictly private reasons, Ruskin began to distance himself from Millais and became more critical of him. The two had become friends in 1853, when Ruskin's wife posed for *The Order of Release, 1746.* That summer all three went on holiday to Scotland, to Glenfinlas, where Millais painted a portrait of Ruskin against a mountain stream. He found it difficult to finish the painting and it was not completed until December 1854. Meanwhile, their friendship had given way to open animosity: during that stay in Scotland, Millais had fallen in love with Effie Ruskin. In 1855 he married her, after she had divorced Ruskin for non-consummation of their marriage.

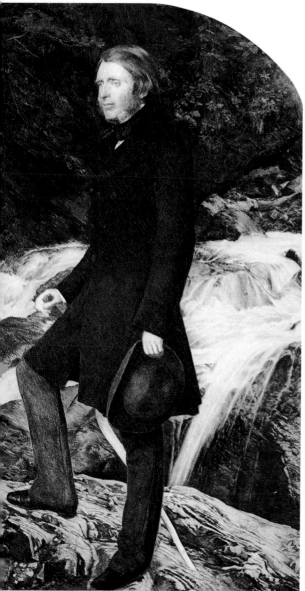

This portrait (1853–4; left) reflects the influence Ruskin had for a while over Millais. It is a perfect synthesis of Ruskin's ideas. The careful observation and meticulous rendering of nature are not only the setting for the portrait but also serve as a meditation on the transitory (water) and the permanent (the rocks). While Millais was working on this painting, Ruskin wrote his father a kind of confessional letter in which he revealed his need to control the artists who interested him: '[Millais is] an interesting study, but I don't know how to manage him.'

The subject of *The Order of Release, 1746* (1852–3; opposite) is drawn from Scottish history and is concerned with the release of a Jacobite rebel imprisoned by the English. The painting was originally entitled *The Ransom*, but the painter soon abandoned the reference to money in favour of this more neutral title. Nevertheless, there remains some ambiguity about the nature of the price paid by this young woman with her enigmatic expression. She was modelled on Effie Ruskin.

Fresh success

At the same time as the Brotherhood was rapidly falling apart, it paradoxically found followers who took up, in whole or in part, their original ideals. Some painters, such as Henry Alexander Bowler and William Shakespeare Burton, produced little more than one painting that could be associated with the movement, while others had stronger links, such as Arthur Hughes, who discovered the Pre-Raphaelites after reading *The Germ* and was strongly influenced by Millais. In the end, the Pre-Raphaelite movement was not restricted to the art world of London centred round the Royal Academy. In fact, it became a

Thomas Combe (above, in a painting by Millais of 1850) bought works by Hunt, Millais and Collins from the year 1850 and most of them now form the Pre-Raphaelite collection in the Ashmolean Museum in Oxford. He was one of the first, though not the only, major collectors and patrons of the Pre-Raphaelites.

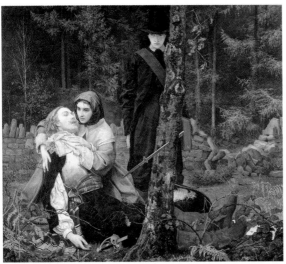

national phenomenon, not only thanks to the reproduction of engravings of Pre-Raphaelite works but also because of new commissions by the middle classes living in large commercial and industrial centres such as Birmingham, Manchester and Liverpool. This sort of patronage had led to the success of Victorian genre painting around the 1830s and 1840s. The majority of collectors bought these

With *The Wounded Cavalier* (1855; left), William Shakespeare Burton was briefly associated with the Pre-Raphaelites. Although this depiction of the civil war was particularly admired by Ruskin, it lacks the symbolic richness and pictorial power that the best of the Brotherhood could achieve.

modern paintings because they were free from the cultural prejudices of the aristocracy, who traditionally collected old masters. Thomas Combe was a good representative of this phenomenon; superintendent of the Oxford University Press and a prominent figure in the Tractarian Movement, he was one of the first to support the Pre-Raphaelites by buying their paintings.

A typical example of this flourishing provincial patronage, Liverpool became one of the main centres of support for Pre-Raphaelitism. Every year the Liverpool Academy showed a large selection of Pre-Raphaelite paintings, which led to the emergence there of a group of artists very strongly influenced by the movement, such as William Davis (1812–73) and William Lindsay Windus (1822–1907).

The Pre-Raphaelites were also given important private commissions, for instance by Lady Trevelyan for Wallington Hall, her country residence outside Newcastle. The house contains a series of murals depicting the history of Northumberland that she commissioned from William Bell Scott, the last of which, the descriptive composition *Iron and Coal* (c. 1855–60), owes much to Brown's *Work*. There are also works by Rossetti, Woolner and Munro.

Ruskin showed such enthusiasm for Arthur Hughes' *April Love* (1855; below), praising its colour and subtlety in his *Academy Notes* for the 1856 Royal Academy exhibition, that, after reading them, William Morris, who was still a student at the time, decided to buy the painting.

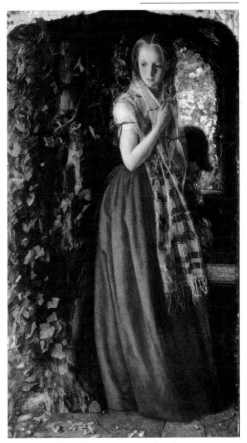

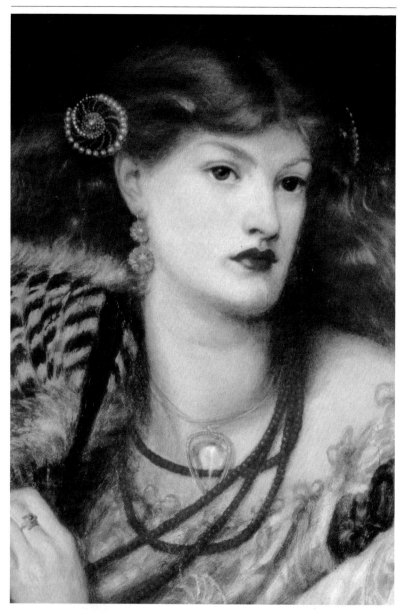

'But with this newer school – with Rossetti especially – we feel at once that Nature is no more than an accessory. The most direct appeals, the most penetrating reminiscences, come to the worshipper of Beauty from a woman's eyes.'

Frederick William Henry Myers,
Rossetti and the Religion of Beauty
in *Essays Modern*, 1887

CHAPTER 4

ARTISTIC CAREERS
(1857–70)

Rossetti wrote of *Monna Vanna* (opposite) in 1866: 'I have a picture close on completion – one of my best I believe, and probably the most effective as a room decoration which I have ever painted…in short the Venetian ideal of female beauty.' Right: a 1916 caricature by Max Beerbohm of Morris and Burne-Jones, the leading figures in the second generation of Pre-Raphaelites.

During the 1850s, Rossetti, who had decided not to exhibit in public any more, became a legendary figure. The constantly auto-biographical aspect of his work was a modern version of the Romantics' self-heroization. Rossetti's aura and the fascination with his work made him the central figure around whom younger artists such as William Morris and Edward Burne-Jones gravitated.

Rossetti wrote to his brother in 1855 that he thought Burne-Jones (photographed in 1874, left) was 'one of the nicest young fellows in Dreamland'.

Burne-Jones described Morris (below, in 1857) at the time when they were studying in Oxford as 'one of the cleverest fellows I know.... He is full of enthusiasm for things holy and beautiful and true, and what is rarest, one of the most exquisite perception and judgment in them.... If it were not for his boisterous mad out-bursts and freaks, which break the romance he sheds around him – at least to me – he would be a perfect hero.'

The 'second generation' of Pre-Raphaelites

The long and close friendship between Edward Burne-Jones (1833–98) and William Morris (1834–96) began in Oxford, in 1853, when they started reading theology at Exeter College. Their family backgrounds were totally different. Burne-Jones, from a fairly modest family in Birmingham, spent a solitary childhood in a family stricken by his mother's death at his birth. William Morris, by contrast, came from a well-to-do London family and had a protected and privileged childhood. They were united in their passion for medieval culture and, initially, by their interest in the ideas of the Oxford Movement, though they soon turned to Christian Socialism and then to the social criticism of Carlyle and Ruskin.

In 1855 their encounter with the Arthurian cycle, in Thomas Malory's version of *Morte d'Arthur* (1485), proved a real revelation, especially for Burne-Jones, and it impressed its literary and romantic seal on his entire work. A journey to France in the same year to discover the French cathedrals confirmed the two young men in their artistic vocation. From this time on Burne-Jones focused

on painting and Morris on architecture. This decision was fuelled by their discovery of the Pre-Raphaelites through reading Ruskin, visits to the Royal Academy exhibitions and the collection Thomas Combe had assembled in Oxford. When they saw one of Combe's latest acquisitions, a Rossetti watercolour entitled *The*

This watercolour by Rossetti (below) was inspired by Dante's *Vita Nuova*. The poet is interrupted by visitors while drawing an angel on the anniversary of Beatrice's death. The

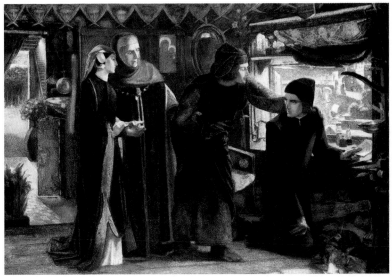

First Anniversary of the Death of Beatrice, Burne-Jones and Morris decided Ruskin was their hero, 'the chief figure in the Pre-Raphaelite Brotherhood'.

In the footsteps of Rossetti

In January 1856 Morris joined the practice of the Gothic Revival architect George Edmund Street, while Burne-Jones went to see Rossetti, who was then teaching at the Working Men's College. The two artists, of much the same age (twenty-three and twenty-seven) felt drawn to each other at once. Then, in the summer of 1856, Morris also met Rossetti, who agreed to contribute to the *Oxford and Cambridge Magazine*, a kind of spin-off from *The*

painter explained: 'I had an idea...that the lady in my drawing should be Gemma Donati whom Dante married afterwards...and in part the sketch is full of notions of my own in this way, which would only be cared about by one to whom Dante was a chief study.' Apart from identifying with the Renaissance poet, Rossetti affirms that he belongs to a thriving culture that alone can inspire a new era.

Germ that he had recently launched and financed (it folded after twelve issues). Rossetti induced Burne-Jones to paint after giving him some lessons and also tried to persuade Morris, though with less success.

They became much closer friends when Burne-Jones and Morris moved to London, to 17 Red Lion Square, the same house in which Rossetti and Deverell had lived when the Brotherhood was founded. They soon filled it with medieval objects of all kinds, arms, manuscripts, enamels, engravings by Dürer, whom both artists greatly admired, and furniture decorated by themselves and by Rossetti. The same kind of atmosphere, only more so, pervaded the Red House in Bexleyheath, Kent, the house Morris had designed for him by Philip Webb (1831–1915) in 1859, the year he married Jane Burden whom he had met in Oxford. The decoration

When he was young, Burne-Jones found it difficult to paint in oils because of his delicate health. His first major works were extremely accomplished pen-and-ink drawings that betray the influence of Rossetti and the ideas of Ruskin as set out in *The Elements of Drawing* (1857). His medieval taste is reflected in the subject – courtly love – and the treatment of *The Knight's Farewell* (1858; below), which was also influenced by Dürer's engravings.

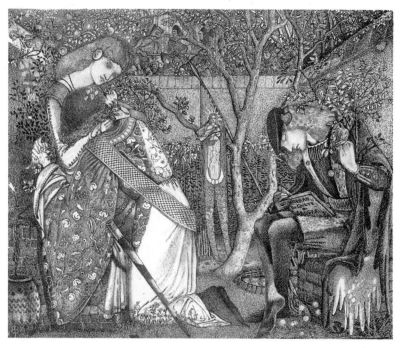

and furniture of this house, which became known as the Palace of Art, were designed by Morris, Burne-Jones, Rossetti, Elizabeth Siddal and others. This work was the inspiration for Morris' firm, Morris & Co., in 1861.

Rossetti probably felt that with these newcomers a second Pre-Raphaelite group was beginning to take shape. Indeed, a number of events took place from 1857 to 1858 that brought together the two generations of artists, not only reflecting the vitality and public recognition of the ideas set out nearly a decade ago but also their development: semi-public showings of Ford Madox Brown's paintings and watercolours in July 1857, a travelling exhibition of English (and especially Pre-Raphaelite) art in New York, Philadelphia and Boston.

Finally, the Hogarth Club, created in April 1858, counted among its members almost everyone connected with the Pre-Raphaelites, with the exception of Millais and Collinson: Brown, Rossetti, Burne-Jones, Ruskin, George Frederick Watts, Algernon Swinburne, George Edmund Street, Philip Webb, George Price Boyce and John Brett. The club, which closed down in December 1861, also held exhibitions. The first one, held in January 1859, showed works by Burne-Jones (including *Going to the Battle* and *The Knight's Farewell*).

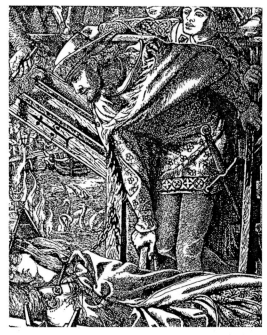

Hunt, Rossetti, Millais and Woolner joined forces to work on an illustrated edition of Tennyson's *Poems*, published by Edward Moxon in 1857. Rossetti contributed five illustrations, one of them for 'The Lady of Shalott' (above). To show the arrival in Camelot of the body of the ill-fated heroine in a boat borne by the current, he enclosed his composition in a very tight framework, which takes away any overly narrative effect from the image and accentuates the mystery of the scene.

The Oxford Union frescoes

The murals for the Oxford Union were the most famous collective work of that period. Rossetti had gone to Oxford to see his friend, the Dublin architect Benjamin Woodward, who was working on the university's new museum and on a new debating hall for the Oxford Union. Impressed by the decoration of Merton College Chapel, renovated by the architect William Butterfield, with a painted ceiling by John Hungerford Pollen, Rossetti persuaded Woodward to let his group of painter friends decorate the walls above the gallery that encircles the debating hall.

Burne-Jones, Morris, Pollen and Rossetti himself, assisted by Spencer Stanhope, Val Prinsep and Arthur Hughes, together with Munro who sculpted a tympanum, launched themselves into an adventure that came to be regarded not only as one of the high points of the Pre-Raphaelite period but also as one of its great failures, in technical terms at least. The project was for ten frescoes illustrating the *Morte d'Arthur*.

Sir Launcelot's Vision of the Sanc Greal (1857) was the title of the mural Rossetti painted for the debating hall (above).

Burne-Jones called the red-haired Swinburne (below) 'Dear Little Carrots'.

However, apart from Pollen, none of the artists knew anything about fresco technique and the paint flaked off before the murals were completed. It was during that stay that Rossetti discovered the young poet Algernon Charles Swinburne (1837–1909), a student at Balliol College, who became part of the group.

The murals in the debating hall, now the Oxford Union library (left) were painted in the summer of 1857. The artists called this period 'the Jovial Campaign' and Val Prinsep described the extremely relaxed atmosphere and the general veneration for Rossetti as follows: 'What fun we had in that Union! What jokes! What roars of laughter! … He [Rossetti] was the planet around which we revolved. We copied his very way of speaking.… Medievalism was our *beau idéal* and we sank our own individuality in the strong personality of our adored Gabriel.' This enterprise attracted great curiosity at the university and one frequent visitor to the site was Lady Pauline Trevelyan, for whom William Bell Scott was currently painting eight large pictures for her house, Wallington Hall. In the years to come, the Pre-Raphaelite circle became increasingly interested in interior decoration.

High point and end of medievalism

The inspiration the Victorians found in the medieval world, a way of replacing the realities of modern life with romance and chivalry, was the height of fashion. The modern counterpart of *Morte d'Arthur*, which had influenced the Pre-Raphaelites, was the *Idylls of the King* by Alfred, Lord Tennyson, published in 1859 and added to in 1869. It was illustrated by Hunt, Millais, Rossetti and Woolner.

The same Arthurian inspiration recurs in one of the main Pre-Raphaelite literary works, William Morris' *The Defence of Guenevere and other Poems*, published in March 1858. The main poem provides the theme for the only painting Morris ever completed, *Queen Guenevere*, for which his wife Jane was the model. As for Burne-Jones, after *The Merciful Knight*, he finally abandoned this archaizing mysticism. Ruskin himself was becoming irritated by the medievalist fad that he regarded as a danger to the representation of nature. Pre-Raphaelitism could not remain an innovative movement unless it went beyond this stifling approach.

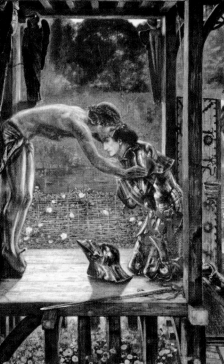

Burne-Jones' *Merciful Knight* (1863) captures the spirit of Arthurian legend.

Millais finally distances himself from the Pre-Raphaelites

Millais was the first of the group to depart from the rigid thematic and stylistic rules. In three paintings – *The Blind Girl*, *Autumn Leaves* and *Spring* – he prefigured the early works of the Aesthetic Movement, whose aim was to free creative work from any outside justification by setting out the doctrine of what is known as 'art for art's sake'.

The Blind Girl, begun in autumn 1854 in Winchelsea in Sussex and completed in 1856 in Annat Lodge in Perth, Scotland, treats the very

Morris is supposed to have written on one of the preliminary drawings for *La Belle Iseult* (1858), also known as *Queen Guenevere* (opposite, modelled on Jane Morris): 'I cannot paint you, but I love you.'

distressing social problem of vagrancy amongst children and the disabled. Avoiding any sentimentalism, Millais painted a communion with nature filled with moving symbolism.

According to his wife, Effie Millais, *Autumn Leaves* is 'a picture full of beauty and without subject', in which the artist boldly tries to represent a feeling.

The painting is melancholic but at the same time a meditation on the passage of time and the inevitability of death, which will come to the young girls one day despite their youth. One source of inspiration for the painting was the poetry of Tennyson, which Millais admired greatly, especially 'Tears, Idle Tears' from *The Princess*.

Finally, *Spring* (also known as *Apple Blossoms*), painted between 1856 and 1859, again in the house in Perth, is a kind of antithesis to *Autumn Leaves*. In its harmonious and decorative composition, full of almost indecipherable details, the scene is closer to James Abbott McNeill Whistler's investigations into form than to a classic Victorian genre scene. It was shown at the Royal Academy in 1859 alongside *The Vale of Rest*, its mystical counterpart.

These paintings were poorly received on the whole and Millais returned to more conventional narrative painting. He then embarked very successfully on a second, far more conventional career. The new approach he took to art, heavily influenced by the

Brown said that *The Blind Girl* (left) was 'altogether the finest subject, a glorious one, a religious picture'. Rossetti thought the painting was 'one of the most touching and perfect things I know'.

Referring to *Autumn Leaves* (1855–6; opposite), Millais wrote: 'I have always felt insulted when people have regarded the picture as a simple little domestic episode, chosen for effect, and colour, as I intended the picture to awaken by its solemnity the deepest religious reflection.'

paintings of Velazquez and Frans Hals, finally distanced him from the Pre-Raphaelites.

Another Italy

In 1860, in the final volume of *Modern Painters*, Ruskin openly paid tribute to Venetian painting. Theorists and artists, aware that the references to medieval and pre-Renaissance sources were becoming too repetitive and predictable, decided to look to a different kind of Italian art. In an attempt to turn Burne-Jones away from his medieval and overly dramatic aesthetic approach, Ruskin encouraged him to go to Italy. Burne-Jones made his first trip there

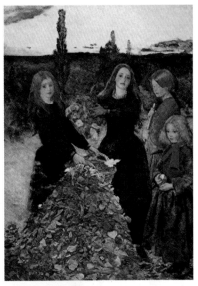

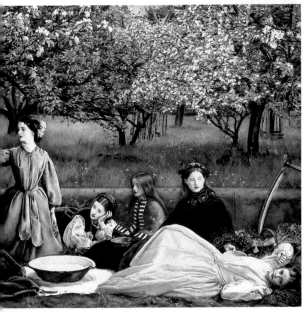

When Millais began to work on *Spring* (left), he was anticipating Ruskin, who wrote in 1858: 'How strange that among all this painting of delicate detail, there is not a true one of English spring!' Under the guise of a Victorian *déjeuner sur l'herbe*, this painting remains in many respects mysterious. Its echo of Botticelli's *Primavera* – in the frieze-like arrangement of the figures against an orchard background – contrasts with the sense of isolation and indifference of the figures, due perhaps to the influence of the collages and photographic montages so fashionable at the time.

in the autumn of 1859, with Val Prinsep, and a second one in 1862 with Ruskin himself, to make copies for Ruskin of paintings and frescoes by Tintoretto, Titian, Veronese and Bernardino Luini. A little later, Swinburne started the cult of Botticelli. It was then taken up by the art critic Walter Horatio Pater (1839–94), who published an essay on Botticelli in August 1870 and wrote of him in his *Studies in the History of the Renaissance* in 1873, alongside chapters on Michelangelo and Leonardo da Vinci, amongst others.

Burne-Jones' *Sidonia von Bork* and *Clara von Bork* reveal the aesthetic shift that took place in the early 1860s. Inspired by a story by Wilhelm Meinhold that was first published in English in 1849 as *Sidonia the Sorceress* (in a translation by Lady Wilde, Oscar Wilde's mother), a great favourite of Rossetti and his circle, these two watercolours draw on medieval and Renaissance sources.

Rossetti and Elizabeth Siddal: a Dantean love duet

After finally abandoning any fidelity to nature, Rossetti returned to poetry and illustration. It was then that he fell in love

Rossetti did many life drawings of Elizabeth Siddal, some of which he later used as sketches for paintings. One is this study for Rachel (left) in *Dante's Vision of Rachel and Leah* (1855), a watercolour commissioned by Ruskin.

Clerk Saunders by Elizabeth Siddal (1857; below) was inspired by one of the Scottish ballads collected by Sir Walter Scott. Clerk Saunders was killed by the brothers of his mistress May Margaret because of his lowly status and his ghost appeared to the young woman at the window of her bedchamber, beseeching her to return to her faith.

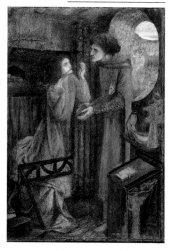

with Elizabeth Siddal (the model Millais used for Ophelia) and their intense relationship profoundly affected his life and career. The house in Chatham Place to which they moved in 1852 was the backdrop to their complex and passionate love affair, in which Elizabeth Siddal became his obsessional model and his artistic double.

Burne-Jones' *Sidonia von Bork* (below) was inspired by Guilio Romano's portrait of Isabella d'Este in Hampton Court.

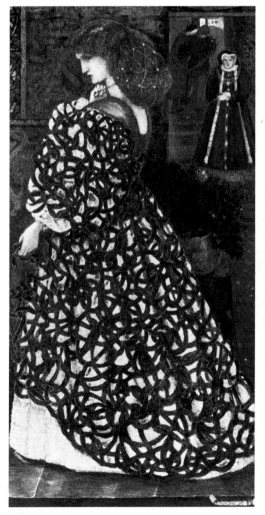

From the start of their relationship, Rossetti guided and encouraged her to draw and to compose poetry. Although the young woman's poems were not widely known, her graphic work soon gained a considerable reputation. From 1855 to 1857 John Ruskin gave her a kind of allowance in exchange for all her works. They showed a strong resemblance to Rossetti's, reflecting a claustrophobic and fascinating love affair.

Rossetti himself projected his passionate feelings for her into paintings illustrating the story of Dante and Beatrice, such as *Paolo and Francesca da Rimini* (1855) and *Dantis Amor* (1859–60; this panel was originally the centre door out of three on the upper section of a large settle

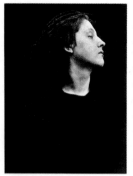

that was part of Morris' furniture at Red Lion Square and then at the Red House), which share the same two-dimensional treatment and decorative stylization. This same stylistic trend is found in Rossetti's illustrations from 1855 on.

Rossetti was torn between his idealized love for Elizabeth Siddal and his liaisons with some of his other models: Fanny Cornforth, a Soho prostitute, and Annie Miller, who was also Hunt's mistress. He eventually married Siddal in 1860, though it was probably too late by then. The young woman, whose fragile health continued to decline, died like a true modern romantic heroine of an overdose of laudanum in February 1862. It was unclear whether her death was as a result of suicide or not.

From *Bocca Baciata* to *Beata Beatrix*: two visions of woman

Rossetti returned to oil painting rather suddenly in 1859, with *Bocca Baciata*, whose composition and palette is strongly influenced by the sensuality of Venetian rather than Florentine painting. The picture is generally regarded as a seminal work of the early Aesthetic Movement, which reacted against the idea that art must serve a purpose. The title is drawn from Boccacio's *Decameron*: *Bocca baciata non perda ventura, anzi rinnuova come fa la luna* (the mouth that has been kissed loses not its

Rossetti explained the intention behind *Beata Beatrix* (below) on 11 March 1873: 'The picture must of course be viewed not as a representation of the incident of the death of Beatrice, but as an ideal of the subject, symbolized by a trance or sudden spiritual transfiguration. Beatrice is rapt visibly into Heaven, seeing as it were through her shut lids.' There is a striking thematic and stylistic similarity with Julia Margaret Cameron's photograph *Call, I Follow* (1867; left), inspired by a poem by Tennyson. An exploration of the psyche is translated with the same visionary sense.

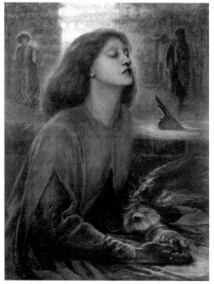

freshness; still it renews itself even as does the moon). The model for this painting commissioned by his painter friend George Boyce was Fanny Cornforth, the mistress of both men. Rossetti confided to Boyce that, as he worked on the painting, 'it has taken after all a rather Venetian aspect', thus confirming the emergence of new visual sources. *Bocca Baciata* began the impressive series of paintings of women by Rossetti, including *Veronica Veronese, The Blue Bower* and *The Beloved*.

After the death of Elizabeth Siddal, Rossetti moved to Tudor House in Chelsea. There he lived an increasingly eccentric life, surrounded by exotic animals, and began his long descent into the hell of drugs and alcohol. Between 1864 and 1870 he painted *Beata Beatrix,* a work that breaks completely with the sensual and luminous visions of women that marked his work after *Bocca Baciata*. This painting is a memorial to Elizabeth Siddal, in which the painter compares his dead wife to the Beatrice of *Vita Nuova* and identifies with the grieving Dante. The blurred quality of the painting may have been inspired by the photographs taken by Julia Margaret Cameron, which Rossetti greatly admired. This kind of timelessness between life and death, the sensual and the spiritual, looks forward to the hypnotic states that the Symbolist painters explored. Rossetti returned to Dante one last time after this painting, with *Dante's Dream* (1871), a work also linked to Siddal's death.

Bocca Baciata (below), with its 'gross sensuality', could not fail to shock Hunt. He complained in a letter to Thomas Combe of 12 February 1860 that while 'most people speak to me of it as a triumph of *our school*... I will not scruple that it impresses me as very remarkable in power of execution – but still more remarkable for gross sensuality of a revolting kind...I would not speak so unreservedly of it were it not that I see Rossetti is advocating as a principle the mere gratification of the eye'.

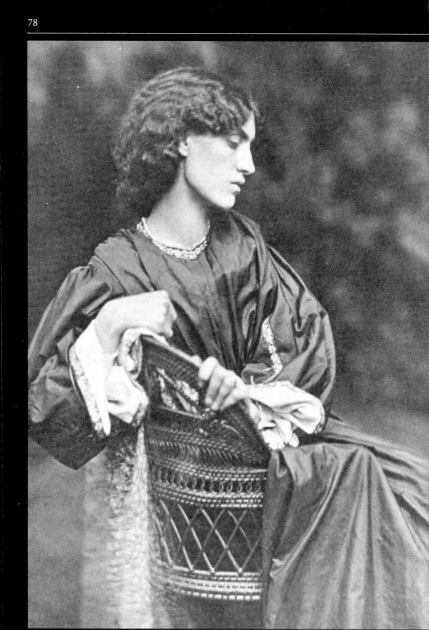

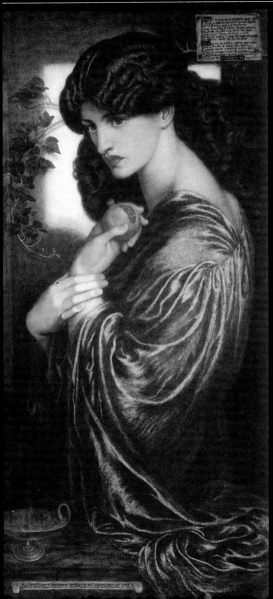

Jane Morris (opposite) became Rossetti's muse during the final part of his career. The true nature of their relationship remains uncertain; in any case they were very close from 1869 on. Rossetti took numerous photographs of her – many of them in the garden of his house in Cheyne Walk in Chelsea – for use as studies for paintings.

Proserpine (1873–7; left) is one of the many variations on literary and mythological themes inspired by the sensual and pensive beauty of Jane Morris. His goddess is shown as Empress of Hades, condemned to divide her time between the underworld and earth after eating one grain of a pomegranate, which placed her for ever in the power of Pluto, her new bridegroom. Rossetti pointed out to W. A. Turner, who commissioned one of the eight versions he painted: 'She is represented in a gloomy corridor of her palace, with the fatal fruit in her hand. As she passes, a gleam strikes on the wall behind her...admitting for a moment the light of the upper world; and she glances furtively towards it, immersed in thought.'

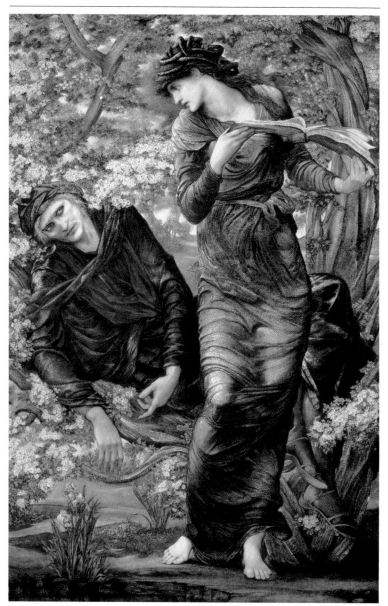

'I mean by a picture a beautiful romantic dream of something that never was, never will be – in a light better than any other light that ever shone – in a land no one can define or remember, only desire.'

Edward Burne-Jones

CHAPTER 5

TOWARDS SYMBOLISM
(1871–98)

Towards the end of the movement, Burne-Jones still stood for renewal. Opposite: *The Beguiling of Merlin* (1870–4) was exhibited at the Grosvenor Gallery in 1877. His work was influenced by his collaboration with Morris on the decorative arts. Right: a jewellery case decorated by Rossetti and Elizabeth Siddal, a wedding present to Jane Morris.

In the 1870s the second generation of Pre-Raphaelites – headed by Burne-Jones and Morris, each in their own way – came to the forefront. Burne-Jones, the main representative of the Aesthetic and then the Symbolist aspirations of the movement, dominated the English painting of the time. Morris, deeply committed to his art, used his strong personality to promote the causes he regarded as important.

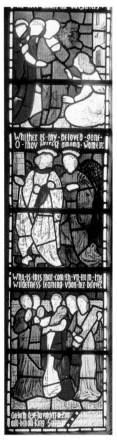

Whither is thy ·beloved ·gone·
O·thou fairest amang·women·

who·is·this that·com·th·vp·fro·m·the
wilderness leaning·vpon·her·beloved·

Go·forth·O·ye·davghters·of·Zion·
and·behold·King·Solomon·

With William Morris, Pre-Raphaelitism enters the decorative arts

In the arts and crafts movement, William Morris' work perfectly embodies the trend away from medieval and archaizing sources towards an increasingly subtle and sophisticated approach to ornamental and decorative art. After the decoration of the Oxford Union and the Red House, Morris turned to research and the design of furniture and interiors, while remaining committed to Pre-Raphaelite idealism.

In 1861 he founded the Firm, under the title 'Morris, Marshall, Faulkner & Co.', whose main collaborators were Ford Madox Brown, Philip Webb, Rossetti and, intermittently, Arthur Hughes and Simeon Solomon. The Firm designed and decorated interiors and made furniture, stained glass, tiles, tapestries,

William Morris always had a very strong political views, which took various forms over the course of time. A Liberal in the 1870s, he became a member of the Democratic Federation in 1883 and even designed its membership card (above). He then helped found the Socialist League in 1884. His social and political concerns lie at the heart of his *News from Nowhere*, inspired by Engels, which he published in 1891. With his interest in medieval architecture, he founded the Society for the Protection of Ancient Buildings ('Anti-Scrape') in March 1877.

When he embarked on his decisive journey with Burne-Jones in 1855 to discover the northern French cathedrals, Morris recognized the important role stained glass could play in architecture. Left: stained-glass window (1862) in the church at Darley Dale in Derbyshire, based on a design by Morris.

wallpaper, textiles and ironwork. Between 1866 and 1867 the Firm was entrusted with a public commission for the South Kensington Museum (now the Victoria and Albert Museum) for a tea room, the Green Dining Room. Designed by Philip Webb, the decoration broke with the medieval style and adopted a lighter and more classicizing tone.

In 1875, after a personal disagreement with Rossetti and Brown, Morris took over sole responsibility as manager of the enterprise then known as Morris & Co., which retained this name until 1940. For ten years it manufactured some of the best-known decoration in England, if not in Europe, even opening a showroom in Oxford Street in 1877. In 1881 Morris & Co. moved all its work to studios in Merton Abbey in Surrey, near Wimbledon.

When the Arts and Crafts Exhibition Society was founded in 1887, Morris quite naturally became both the inspiration and leader of what was known as the Arts and Crafts Movement. In his work, Morris managed to reconcile commercial requirements with a style that remained

The *Woodpecker* tapestry (above) was woven in 1885 after a design by Morris himself and shown at the second Arts and Crafts Exhibition in 1888. Morris was also responsible for the *Birds* textile motif covering the chair (left), which Philip Webb designed for the Firm in 1878.

In 1878 William and Jane Morris moved to a house in Hammersmith, overlooking the Thames, which they christened Kelmscott

House in memory of their former home, Kelmscott Manor in Oxfordshire. The drawing-room (left) reflects the lifestyle of Morris who liked to combine his own creations – the *Birds* motif on the wall-hangings and the *Peacock and Dragon* motif on the woven woollen curtains – with his collections of objects and antiquarian books. The *Jasmine* wallpaper (above), created around 1872, shows the quality and inventiveness of Morris' design. Burne-Jones used it to decorate a room in his house, The Grange, in Fulham.

Pre-Raphaelite in the naturalism of the decorative motifs and the archaizing style of the furniture; in a sense the group spirit had found a second wind in its faith in workmanship and in its belief in an ideal community.

The Kelmscott Press: the revival of the illustrated book

Of all his various enterprises, Morris' printing and publishing activities were perhaps closest to the Pre-Raphaelite spirit. He was largely instrumental in the revival of the illustrated book, essentially Symbolist in style, throughout Europe at the end of the century. In the late 1880s Morris founded the Kelmscott Press, which published its first work in 1891. A bibliophile with a passionate interest in calligraphy and a great collector, fascinated by late 15th-century works, he tried to re-create the Late Gothic spirit in his attention to the page design, the typography and even the

THE MUSIC.

LOVE IS ENOUGH: cherish life that abideth,
Lest ye die ere ye know him, and curse and misname him;
For who knows in what ruin of all hope he bideth,

quality of the paper he used (vellum for the luxury editions). The Kelmscott Press published more than sixty volumes, most of which were either written by Morris himself or were medieval texts. Burne-Jones helped design them, as did, to a lesser extent, Walter Crane. The illustrated collection of Chaucer's works was the masterpiece and ultimate example of the

The first editions of Chaucer's works (opposite, a page from the collection) were published in June 1896, four months before Morris died. Above: an extract from the poem *Love is Enough*, published by the Kelmscott Press in 1898.

'It was the essence of my undertaking to produce books which it would be a pleasure to look upon as pieces of printing and arrangement of type,' said Morris. He designed not only all the page layouts of the books published by the Kelmscott Press, but also the typography, the dropped initials and the illuminations, creating new typefaces for his major publications, such as the 'Chaucer' typeface for works by Chaucer. Left: a photograph of Morris' assistants printing an edition of the Kelmscott Chaucer.

collaboration between Morris and Burne-Jones in this field. The eighty-seven illustrations by Burne-Jones are free of any reference to literal narrative and perfectly evoke the atmosphere of the Middle Ages.

Burne-Jones, designer and painter

In 1870 Burne-Jones resigned from the Old Water-Colour Society which had forced him to withdraw his *Phyllis and Demophoön* from an exhibition of watercolours it had organized

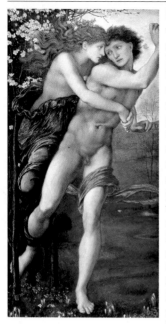

because his male nude was considered shocking. In fact, Burne-Jones had broken the Victorian taboo on representing the nude body in painting. This sudden trend towards a more sensual painting reflected his personal situation and his passionate love affair with a young artist and model of Greek origin, Maria Zambaco. His resignation from the Old Water-Colour Society deprived Burne-Jones of his usual place to show his work to the public.

Over the next seven years he exhibited very little and was supported by a few patrons, notably Frederick Leyland, the shipping magnate and collector, and William Graham, a manufacturer and Member of Parliament. His relationship with Ruskin became more distant after 1871 when Ruskin attacked Michelangelo, now one of Burne-Jones' main points of reference. The old, close ties between the group also weakened when, in 1872, Rossetti fell into a severe depression from which he never recovered and when Morris took over the Firm.

'The art of culture, of reflection, of intellectual luxury, of aesthetic refinement' (Henry James)

Burne-Jones returned to Italy in 1871 and 1873, in search of an aesthetic style that would finally distance him from what he regarded as the over-exactitude of Pre-Raphaelitism.

The Golden Stairs (1876–80; opposite) is a work very close to the Aesthetic movement that foreshadowed Symbolism, which stressed the importance of symbols rather than representation. This 'subjectless' composition is a formal variation on the theme of music. The repetitive harmony of the procession of maidens carrying musical instruments is evocative of an imaginary music score. This work fascinated the Belgian Symbolist painter Fernand Khnopff.

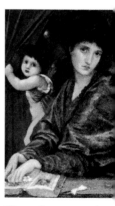

Burne-Jones executed this portrait of Maria Zambaco (1870; above) towards the end of their liaison. The young woman's features recur in other works of his, such as *Phyllis and Demophoön* (1870; left).

The paintings of Mantegna, Signorelli, Botticelli and Michelangelo now became the most important influences in his work. Evidence of his mature style came in 1877, with the first exhibition at the Grosvenor Gallery, which had recently been founded by Sir Coutts Lindsay to offer space to those artists who had been rejected by, or poorly represented at, the Royal Academy. This new sensibility was very aptly perceived and analysed by the writer Henry James: 'It is the art of culture, of reflection, of intellectual luxury, of aesthetic refinement, of people who look at the world not directly, as it were, and in all its accidental reality, but in the reflection and ornamental portrait of it furnished by art itself in other manifestations; furnished by literature, by poetry, by erudition.'

From that moment Burne-Jones enjoyed national and then, from the 1880s, international recognition. His success can be explained by his deliberate decision to

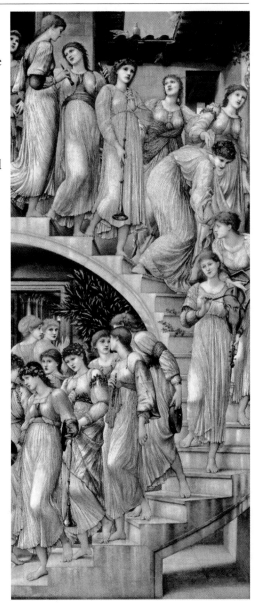

devote his art entirely to the imagination. In opting to escape from reality, he was sharing one of the aspirations of the nascent Symbolist movement, which was based on the criticism of contemporary materialism. He gave back to the old archaizing, medievalizing inspiration of Pre-Raphaelitism, which he also opened up to classical mythology, a precision of expression and an emotional charge imbued with nostalgia.

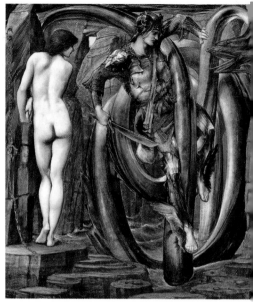

The cycles of legends: achieving the impossible

Inspired by his reading of mythological and medieval tales, Burne-Jones conceived many of his paintings and decorative works on a grand scale, consisting of a number of panels, often uncompleted. At times the scale became almost monumental, as in the works he produced from the 1870s.

This monumental approach, intended as a modern equivalent to 15th-century painting, took various forms. For instance, the ambitious *Triptych of Troy* remained incomplete, but some of its elements were developed into separate works (*The Feast of Pelleas, Venus Discordia, The Wheel of Fortune*). The *Briar Rose* series, whose origins date back to the early 1860s, to a panel on the theme of Perrault's Sleeping Beauty, gave rise to two series of paintings: the first, 'small-scale' one from 1870 to 1873, then a larger-scale one which took another ten years to finish. Of Burne-Jones' masterpiece of decorative painting, the *Perseus* cycle commissioned in 1875 by Arthur

Arthur Balfour left Burne-Jones to choose the theme for the decoration of his music room. The painter opted for the story of Perseus, after a narrative version by William Morris taken from *The Earthly Paradise*. The epic and visionary spirit of the work reveals an almost experimental sculptural freedom unparalleled in his work. In *The Doom Fulfilled* (1884–5; above), which shows Andromeda being released by Perseus, he created a daring erotic contrast between the female nude and the armour of the hero and metallic coils of the monster of the sea.

Balfour – the politician and future prime minister – for the music room of his London residence, only the series of full-sized gouaches was completed.

However, Burne-Jones was able to satisfy his ambition for decorative arts on a monumental scale (stained glass and tapestry), when he became one of

In *The Baleful Head* (1886–7; below), Burne-Jones represents Perseus showing Andromeda the Medusa's head reflected in a well.

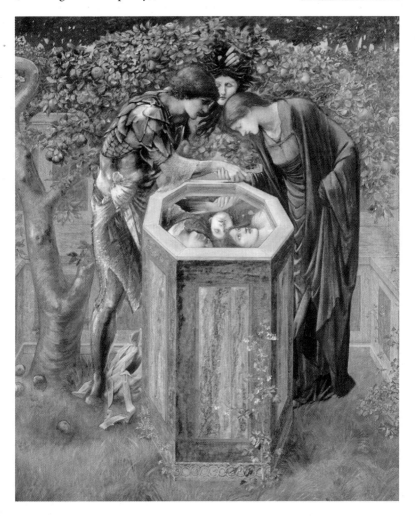

the main designers for Morris & Co. In the late 1880s, the company produced the first large series of tapestries on the theme of *The Adoration of the Magi*. The most impressive outcome of this co-operative effort was the *Holy Grail* cycle, designed for the dining room of Stanmore Hall, the country house of an Australian industrialist, William Knox D'Arcy. This rather Wagnerian ensemble was woven by Morris & Co. at Merton Abbey between 1891 and 1894.

A Symbolist reading

In reaction to the materialism of the modern world and in his search for a meaningful response to the pervading spiritual doubts, Burne-Jones embarked on a ceaseless exploration of ancient legends and myths, a sign that he was coming closer to the world of some of the continental Symbolist painters. The Belgian Symbolist painter Fernand Khnopff wrote in 1899: 'What I liked in the works of some English artists is the precise expression of the sense of legend.' Although Burne-Jones was never a Symbolist in the strict sense of the word, he was aware that they shared similar points of view. Referring to Puvis de Chavannes, he wrote: '[He] has hoisted the same banner as us.' With Burne-Jones, Pre-Raphaelitism for the first and last time acquired a genuine international reputation.

Aubrey Beardsley or perverted Pre-Raphaelitism

Driven into the elitist corner of Symbolism and its legacy, Pre-Raphaelitism rapidly declined into a kind of decadent dandyism, even though there were a few outstanding followers, particularly Aubrey Beardsley.

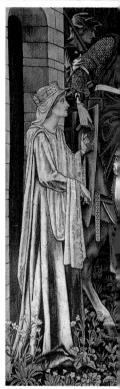

Beardsley's irreverent, cynical and at times parodying interpretation of the text of *Morte d'Arthur* shocked the Pre-Raphaelites. His vision was devoid of any nostalgia for the age of chivalry and he adopted a sarcastic and sexually charged approach to the world of the Round Table. Left: his illustration of *How Sir Tristram Drank of the Love Drink*.

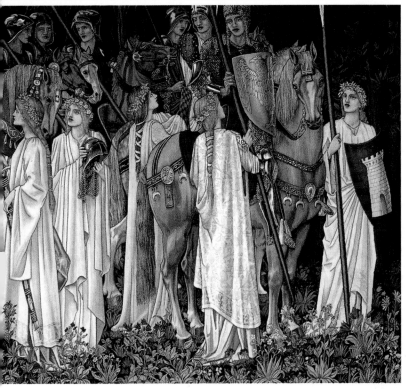

Born in 1872, he encapsulated that generation's admiration for, and also its necessary betrayal of, Rossetti and in particular Morris and Burne-Jones. In the beginning, Burne-Jones had encouraged Beardsley, advised him and even introduced him to Oscar Wilde, whose *Salome* he illustrated three years later. Burne-Jones even hung Beardsley's *Siegfried* beside his Dürer engravings. However, when, in 1892, the bookseller and publisher John Dent commissioned Beardsley to illustrate a new edition of *Morte d'Arthur*, the Pre-Raphaelite literary source *par excellence*, Burne-Jones and, even more so Morris, turned their back on this deeply subversive graphic talent.

Morris and Burne-Jones considered the quest for the Holy Grail 'the most beautiful and complete episode in the [Arthurian] legends' and 'in itself a series of pictures'. *The Arming and Departure of the Knights of the Round Table…* (above) is one of Burne-Jones' most successful group compositions. Using Morris' ideas, he wove silk threads into the tapestry to enhance the colours.

Last reminiscences

The movement proved exceptionally long-lived, no doubt because it had been a national one since the beginning. Hunt remained the most faithful to the Pre-Raphaelite ideals and, with *The Shadow of Death* (1870–3), continued to paint religious works in a spirit of historical truth reminiscent of Ernest Renan's *La Vie de Jésus*, which Hunt had just read. The same marked continuity is found in the work of John William Waterhouse, whose *Lady of Shalott* of 1894 harked back to the subject treated by Hunt.

The last years of Pre-Raphaelitism reflected a fundamentally decorative trend, dominated by the influence of Burne-Jones. The paintings of Evelyn de Morgan, for instance, are a good example of the late 19th-century passion for the art of Botticelli, seen through the filter of Burne-Jones' works. The paintings of John Melhuish Strudwick (1849–1937), a former assistant to Burne-Jones, have similar characteristics. Yet these works do not reflect the same deep understanding of legends and myths, but are merely a formal and decorative exercise, devoid of all creative substance. The real epitaph of Pre-Raphaelitism is perhaps contained in an even later work, John Byam Shaw's *The Boer War 1900–1*, which was shown at the Royal Academy in 1901.

'The rage for me is over' (Burne-Jones, 1897)

With the deaths of many of the major Pre-Raphaelite figures

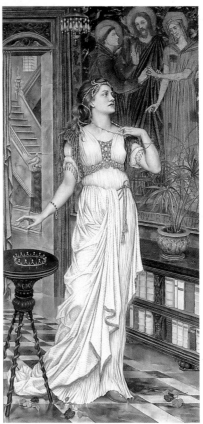

Evelyn de Morgan's *Crown of Glory* (1896; below) shows a rich courtesan taking off her jewellery while looking at a tapestry or fresco depicting the mystical marriage between St Francis and Poverty. It was evidently inspired by a Giotto fresco in Assisi.

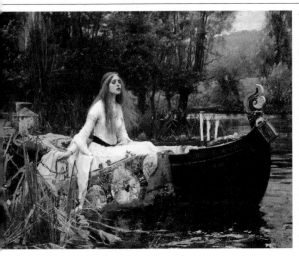

Waterhouse executed a series of three paintings inspired by Tennyson's poem, *The Lady of Shalott.* Despite this Pre-Raphaelite literary influence, the second canvas in the series (left) is given an illusionist treatment. The work of John Melhuish Strudwick, such as this *When Sorrow Comes in Summer Days...* (below), shows the influence of Burne-Jones, mingled with the archaizing classicism that Lawrence Alma-Tadema and Frederic Leighton developed during the 1860s.

Overleaf: a still from *The French Lieutenant's Woman* (1981).

– Rossetti in 1882, Madox Brown in 1893, Millais and Morris in 1896 and Burne-Jones in 1898 – the life-force of a movement that nourished Victorian artistic life for nearly fifty years was extinguished.

For much of the 20th century there was a loss of interest in, and even a rejection of, their works. This change in public opinion largely resulted from a purely formalist and modernist reading of art history that could not fully assess a movement in which modernity and the past were so intimately linked.

The rediscovery of the Pre-Raphaelites that began in the 1960s is an attempt to appreciate anew all the richness, complexity and at times paradoxes of an art that occupies an intriguing position in the history of the 19th century. The Pre-Raphaelites had begun their quest in a spirit of rebellion against the art of their time; today they embody the essence of the great Victorian dream, at the same time archaizing and modern.

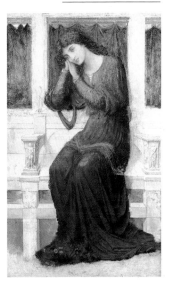

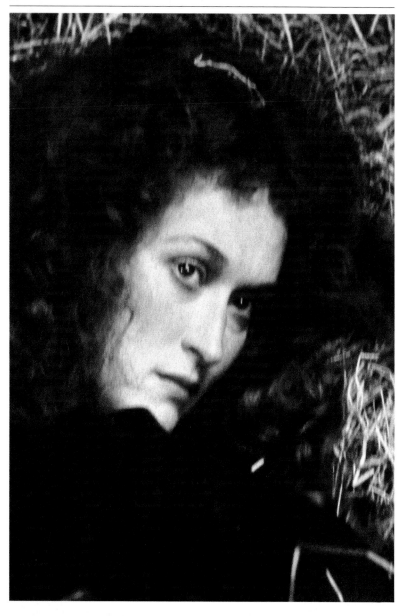

DOCUMENTS

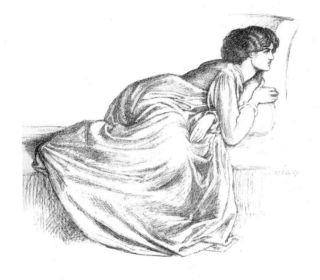

Controversy and misunderstanding

Like all artistic movements that overturned the academic rules of representation, Pre-Raphaelitism gave rise to controversy and scandal. Some critics, such as Charles Dickens, reacted strongly to Pre-Raphaelite paintings. The artists themselves often felt that their work was misunderstood and sometimes explained the intentions that lay behind their works.

Given his reputation, Charles Dickens' violent criticism of the early Pre-Raphaelites had a strong impact. However, paradoxically, his dislike, which he expressed very bluntly, also did the artists a service. For Ruskin responded by writing to The Times *in their defence, thereby initiating a lengthy debate about their art that reflects a mixture of enthusiasm and incomprehension.*

'A Criticism of Millais' *Christ in the House of His Parents*', 1850

You behold the interior of a carpenter's shop. In the foreground of that carpenter's shop is a hideous, wry-necked, blubbering, red-headed boy, in a bed-gown; who appears to have received a poke in the hand, from the stick of another boy with whom he has been playing in an adjacent gutter, and to be holding it up for the contemplation of a kneeling woman, so horrible in her ugliness, that (supposing it were possible for any human creature to exist for a moment with that dislocated throat) she would stand out from the rest of the company as a Monster, in the vilest cabaret in France, or the lowest gin-shop in England....

 Wherever it is possible to express ugliness of feature, limb, or attitude, you have it expressed. Such men as the carpenters might be undressed in any hospital where dirty drunkards, in a high state of varicose veins, are received.

Charles Dickens
Household Words, 15 June 1850

Letter to *The Times*, 7 May 1851

We cannot censure at present as amply or as strongly as we desire to do, that strange disorder of the mind or the eyes which continues to rage with unabated absurdity among a class of juvenile artists who style themselves P. R. B.,

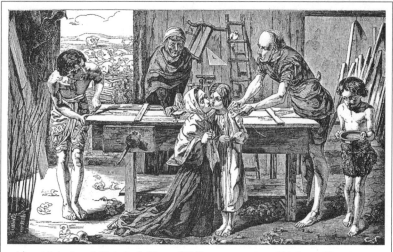

A special viewing of *Christ in the House of His Parents* was arranged for Queen Victoria. 'I hope it will not have any bad effects upon her mind,' Millais wrote to Hunt. Above: an anonymous engraving published in *The Illustrated London News*, 11 May 1851.

which, being interpreted, means Pre-Raphael-brethren. Their faith seems to consist in an absolute contempt for perspective and the known laws of light and shade, an aversion to beauty in every shape, and a singular devotion to the minute accidents of their subjects, including, or rather seeking out, every excess of sharpness and deformity. Mr Millais, Mr Hunt, Mr Collins – and in some degree – Mr Brown, the author of a huge picture of Chaucer, have undertaken to reform the art on these principles. The Council of the Academy, acting in the spirit of toleration and indulgence to young artists, have now allowed these extravagances to disgrace their walls for the last three years, and though we cannot prevent men who are capable of better things from wasting their talents on ugliness and conceit, the public may fairly require that such offensive jests

should not continue to be exposed as specimens of the waywardness of these artists who have relapsed into the infancy of their profession.

Charles Dickens
Letter to *The Times*, 7 May 1851

Letter to *The Times*, 14 May 1851

Sir, – Your usual liberality will, I trust, give a place in your column to this expression of my regret that the tone of the critique which appeared in *The Times* of Wednesday last on the works of Mr Millais and Mr Hunt, now in the Royal Academy, should have been scornful as well as severe.

I regret it, at first, because the more labour bestowed on those works, and their fidelity to a certain order of truth (labour and fidelity which are altogether indisputable) ought at once to have placed them above the level of mere contempt; and, secondly, because I

believe these young artists to be at a most critical period of their career – at a turning point, from which they may either sink into nothingness or rise to very real greatness; and I believe also, that whether they choose the upward or downward path may in no small degree depend upon the character of the criticism which their works have to sustain….

These pre-Raphaelites (I cannot compliment them on common sense in choice of a *nom de guerre*) do not desire or pretend in any way to imitate antique painting, as such. They know little of ancient paintings who suppose the works of three young artists to resemble them. As far as I can judge of their aim – for, as I said, I do not know the men themselves – the pre-Raphaelites intend to surrender to advantage which the knowledge or inventions of the present time can afford to their art. They intend to return to early days in this one point only – that, as far as in them lies, they will draw either what they see or what they suppose might have been the actual facts of the scene they desire to represent, irrespective of any conventional rules of picture making; and they have chosen their unfortunate though not inaccurate name because all artists did this before Raphael's time, and after Raphael's time did not this, but sought to paint fair pictures rather than represent stern facts, of which the consequence has been that from Raphael's time to this day historical art has been in acknowledged decadence.

John Ruskin
Letter to *The Times*, 14 May 1851

Ford Madox Brown on *The Last of England*

Brown's entry in his 1865 catalogue shows the careful consideration he gave to every detail and the meanings that he expected the viewer to discover.

This picture is in the strictest sense historical. It treats of the great emigration movement which attained its culminating point in 1852. The educated are bound to their country by quite other ties than the illiterate man, whose chief consideration is food and physical comfort. I have, therefore, in order to present the parting scene in its fullest tragic development, singled out a couple from the middle classes, high enough, through education and refinement, to appreciate all they are now giving up, and yet depressed enough in means, to have to put up with the discomforts and humiliations incident to a vessel 'all one class'. The husband broods bitterly over blighted hopes and severance from all he has been striving for. The young wife's grief is of a less cankerous sort, probably confined to the sorrow of parting with a few friends of early years. The circle of her love moves with her.

The husband is shielding his wife from the sea spray with an umbrella. Next [to] them in the background, an honest family of the green-grocer type, father (mother lost), eldest daughter, and younger children, makes the best of things with tobacco-pipe and apples, etc., etc. Still further back a reprobate shakes his fist with curses at the land of his birth, as though that were answerable for *his* want of success: his old mother reproves him for his foul-mouthed profanity, while a boon companion, with flushed countenance, and got up in nautical togs for the voyage, signifies drunken approbation. The cabbages slung round the stern of the vessel indicate to the practised eye a lengthy voyage: but for this their introduction

would be objectless. A cabin-boy, too used to 'leaving his native land' to see occasion for much sentiment in it, is selecting vegetables for the dinner out of a boatful.

Millais and his wife on *Autumn Leaves*

Millais wrote to the American critic F. G. Stephens, who had given his painting a favourable review in The Crayon *in 1856.*

I have read your review of my works in *The Crayon* with great pleasure, not because you praise them so much but because you entirely understand what I have intended. In the case of *Autumn Leaves* I was nearly putting in the catalogue an extract from the Psalms, of the very same character as you have quoted in your Criticism, but was prevented so doing from a fear that it would be considered an affectation and obscure. I have always felt insulted when people have regarded the picture as a simple little domestic episode, chosen for effect, and colour, as I intended the picture to awaken by its solemnity the deepest religious reflection. I chose the subject of burning leaves as most calculated to produce this feeling, and the picture was thought of, and begun with that object *solely* in view....

I cannot say that I was disappointed that the public did not interpret my meaning in the *Autumn Leaves* as I scarcely expected so much, and I was not sanguine of my friends either, as I know I am not the sort of man who is accused of very deep Religious Sentiment, or reflection. However as you certainly have read my thoughts in the matter I do not hesitate to acknowledge so much.

Effie Millais tells the story in her journal.

In the background...seizing the moment immediately after sundown, he painted [the] horizon behind Perth, the distant peak of the Ben Vorlich, the Golden sky, the town lost in mist and the tall Poplar trees just losing their leaves. Later he softened it and brought the background into better colour, still magnificently bright. In the lower part of the background he put our lawn and the Apple trees at the foot of the garden, in the front four figures aurified with a Bonfire of Autumn leaves from which smoke issued. The figures were Sophie, Alice [Effie's other sister], Matilda Proudfoot, a girl from the School of Industry, and Isabella Nicol, a little girl from Low Bridgend. All the girls were under 13 years of age and grouped beautiful[ly]. Sophie in the middle is holding a bunch of leaves which are dropping into the basket; Alice is holding it with both hands. It is a large common garden wicker basket. Both the girls are in their winter dresses of green linsey Wolsey, their hair unbound hanging over their shoulders, little frills round their necks and stout walking boots. Matilda is standing with her face half round leaning on a rake or broom for gathering the leaves in a browning [word illegible] cotton dress and cape, the common dress of the School of Industry at that season, her brilliantly red hair glowing against the background of Hills of dark blue. Little Isabella on her side was in purple with her hair, plaited at night, combed straight out in the morning and dressed in Linsey Wolsey purple with a scarlet necktie, a couple of gentianellas in one hand, an Apple in the other. She has fine brown eyes, a pretty like nose and fair hair. She was a great amusement to us she was so old fashioned and thoughtful.

Artist poets

Pre-Raphaelitism is an artistic movement whose literary dimension has always been prominent. Many Pre-Raphaelite works were inspired by religious or historical texts, legends or poems. Yet, in one of the innovative aspects of the movement, a number of Pre-Raphaelite artists expressed themselves as much in words as in images.

'She cries in her locked heart,—/"Leave me —I do not know you— go away!"' D. G. Rossetti, *Found*, and drawing (above).

Rossetti, who was passionately interested in the poetry of the Italian Renaissance and particularly the works of Dante, began writing at the very outset of his artistic career, in the late 1840s, though his first collection of Poems *was not published until 1870. The reason for the lapse in time was because Rossetti had put the manuscripts of his poems in Elizabeth Siddal's coffin on her premature death in 1862. They were only exhumed seven years later. The poem 'Found' is inspired by the painting of the same name, which was never completed.*

'Found'

(For a Picture)

'There is a budding morrow in
 midnight:'—
So sang our Keats, our English
 nightingale.
And here, as lamps across the bridge
 turn pale
In London's smokeless resurrection-
 light,
Dark breaks to dawn. But o'er the
 deadly blight
Of love deflowered and sorrow of none
 avail,
Which makes this man gasp and this
 woman quail,
Can day from darkness ever again take
 flight?

Ah! gave not these two hearts their
 mutual pledge,
Under one mantle sheltered 'neath the
 hedge
In gloaming courtship? And, O God!
 to-day
He only knows he holds her; —but
 what part
Can life now take? She cries in her
 locked heart,—

'Leave me—I do not know you—go
away!'

D. G. Rossetti
Ballads and Sonnets, 1881

'Lost Days'

The lost days of my life until to-day,
What were they, could I see them on the
 street
Lie as they fell? Would they be ears of
 wheat
Sown once for food but trodden into
 clay?
Or golden coins squandered and still to
 pay?
Or drops of blood dabbling the guilty
 feet?
Or such spilt water as in dreams must
 cheat
The undying throats of Hell, athirst
 alway?

I do not see them here; but after death
God knows I know the faces I shall see,
Each one a murdered self, with low last
 breath.
'I am thyself, – what hast thou done to
 me?'
'And I – and I – thyself,' (lo! each one
 saith,)
'And thou thyself to all eternity!'

D. G. Rossetti
Ballads and Sonnets, 1881

*Encouraged by Rossetti, Elizabeth Siddal
also began to write poetry. Her work was
not published during her lifetime. Thanks
to contemporary research and the growing
interest in the position of women in the
Pre-Raphaelite period, Elizabeth Siddal's
strong personality and the quality of
her graphic work and poetry are at last
beginning to be appreciated. The two
poems below, with their haunting
references to death, inevitably bring to
mind the author's tragic fate.*

'Speechless'

Many a mile over land and sea
Unsummoned my love returned to me;
I remember not the words he said
But only the trees moaning overhead.

And he came ready to take and bear
The cross I had carried for many a year,
But words came slowly one by one
From frozen lips shut still and dumb.

How sounded my words so still and
 slow
To the great strong heart that loved me
 so,
Who came to save me from pain and
 wrong
And to comfort me with his love so
 strong?

I felt the wind strike chill and cold
And vapours rise from the red-brown
 mould;
I felt the spell that held my breath
Bending me down to a living death.

Elizabeth Siddal,
written between 1855 and 1859

'Lord May I Come?'

Life and night are falling from me,
Death and day are opening on me,
Wherever my footsteps come and go,
Life is a stony way of woe.
Lord, have I long to go?

Hollow hearts are ever near me,
Soulless eyes have ceased to cheer me;
Lord, may I come to thee?

Life and youth and summer weather
To my heart no joy can gather.
Lord, lift me from life's stony way!

Loved eyes long closed in death watch
 for me:

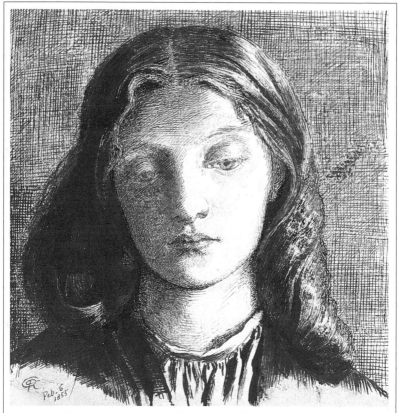

A portrait of Elizabeth Siddal by D. G. Rossetti (1855), revealing her introspective and melancholic character.

Holy death is waiting for me—
Lord, may I come to-day?

My outward life feels sad and still
Like lilies in a frozen rill;
I am gazing upwards to the sun,
Lord, Lord, remembering my lost one.
O Lord, remember me!

How is it in the unknown land?
Do the dead wander hand in hand?

God, give me trust in thee.

Do we clasp dead hands and quiver
With an endless joy for ever?
Do tall white angels gaze and wend
Along the banks where lilies bend?
Lord, we know not how this may be:
Good Lord we put our faith in thee—
O God, remember me.

Elizabeth Siddal,
written between 1855 and 1859

William Morris was a prolific writer and his works include many poems. His first collection, published in 1858 when he was only twenty-four, The Defence of Guenevere and other Poems, *consists of thirty poems whose form varies depending on the subject treated. The title poem of the collection was inspired by the Arthurian legends and reflects the strong medieval style of the Pre-Raphaelite circle at that time. Morris distances himself from Victorian morality by describing a Guenevere who defies those who reproach her with betraying the memory of her husband Arthur by becoming Lancelot's mistress.*

'The Defence of Guenevere'

But, knowing now that they would have
 her speak,
She threw her wet hair backward from
 her brow,
Her hand close to her mouth touching
 her cheek,

As though she had had there a shameful
 blow,
And feeling it shameful to feel ought but
 shame
All through her heart, yet felt her cheek
 burned so,

She must a little touch it; like one lame
She walked away from Gauwaine, with
 her head
Still lifted up; and on her cheek of flame

The tears dried quick; she stopped at last
 and said:
'O knights and lords, it seems but little
 skill
To talk of well-known things past now
 and dead.

'God wot I ought to say, I have done ill,
And pray you all forgiveness heartily!...'

Her voice was low at first, being full of
 tears,
But as it cleared, it grew full loud and
 shrill,
Growing a windy shriek in all men's
 ears,

A ringing in their startled brains, until
She said that Gauwaine lied, then her
 voice sunk,
And her great eyes began again to fill,

Though still she stood right up, and
 never shrunk,
But spoke on bravely, glorious lady fair!
Whatever tears her full lips may have
 drunk,

She stood, and seemed to think, and
 wrung her hair,
Spoke out at last with no more trace of
 shame,
With passionate twisting of her body
 there...

'All I have said is truth, by Christ's dear
 tears.'
She would not speak another word, but
 stood
Turn'd sideways; listening, like a man
 who hears

His brother's trumpet sounding through
 the wood
Of his foes' lances. She lean'd eagerly,
And gave a slight spring sometimes, as
 she could

At last hear something really; joyfully
Her cheek grew crimson, as the
 headlong speed
Of the roan charger drew all men to see,
The knight who came was Launcelot at
 good need.

 William Morris, *The Defence of
 Guenevere and other Poems*, 1858

The everyday life of a Pre-Raphaelite

The American writer Henry James was a close observer and often a very perceptive critic of artistic life in London in the late 19th century.

‘A tall lean woman in a long dress of some dead purple stuff…with a mass of crisp black hair heaped into great wavy projections on each of her temples, a thin pale face, a pair of strange sad, deep, dark Swinburnian eyes.’ Henry James, letter to his sister, 10 March 1869, writing of Jane Morris (right).

In a letter dated 10 March 1869 to his sister Alice James, Henry James writes of his first visit to the Morris household. He gives a very precise description of the sophisticated yet Bohemian atmosphere surrounding the artist, while also paying tribute to Jane Morris' enchanting beauty.

But yesterday, my dear old sister, was my crowning day – seeing as how I spent the greater part of it in the house of Mr Wm Morris, Poet….

Morris lives on the same premises as his shop, in Queen's Square, Bloomsbury, an antiquated ex-fashionable region, smelling strong of the last century, with a hoary effigy of Queen Anne in the middle. Morris' poetry, you see, is only his sub-trade. To begin with, he is a manufacturer of stained glass windows, tiles, ecclesiastical and medieval tapestry, altar-cloths, and in fine everything quaint, archaic, pre-Raphaelite – and I may add, exquisite. Of course his business is small and carried on in his house: the things he makes are so handsome, rich and expensive (besides being articles of the very last luxury) that his fabrique can't be on a very large scale. But everything he has and does is superb and beautiful. But more curious than anything is himself. He designs with his own head and hands all the figures and patterns used in his glass and

'The M's at Ems', a caricature by Rossetti (1869) of William and Jane Morris at Ems, a German spa.

tapestry, and furthermore works the latter, stitch by stitch, with his own fingers – aided by those of his wife and little girls. Oh, ma chère, such a wife! Je n'en reviens pas – she haunts me still. A figure cut out of a missal – out of one of Rossetti's or Hunt's pictures – to say this gives but a faint idea of her, because when such an image puts on flesh and blood, it is an apparition of fearful and wonderful intensity. It's hard to say whether she's a grand synthesis of all the pre-Raphaelite pictures ever made – or they a 'keen analysis' of her – whether she's an original or a copy. In either case she's a wonder. Imagine a tall lean woman in a long dress of some dead purple stuff, guiltless of hoops (or of anything else, I should say,) with a mass of crisp black hair heaped into great wavy projections on each of her temples, a thin pale face, a pair of strange sad, deep, dark Swinburnian eyes, with great thick black oblique brows, joined in the middle and tucking themselves away under her hair, a mouth like the 'Oriana' in our illustrated Tennyson, a long neck, without any collar, and in lieu thereof some dozen strings of outlandish beads – in fine complete. On the wall was a large nearly full-length portrait of her by Rossetti, so strange and unreal that if you hadn't seen her you'd pronounce it a distempered vision, but in fact an extremely good likeness. After dinner (we stayed to dinner, Miss Grace, Miss S.S. and I,) Morris read us one of his unpublished poems, from the second series of his un-'Earthly Paradise', and his wife, having a bad toothache, lay on the sofa, with her handkerchief to her face. There was something very quaint and remote from our actual life, it seemed to me, in the whole scene: Morris reading in his flowing antique numbers a legend of prodigies and terrors (the story of Bellerophon, it was), around us all the picturesque bric-a-brac of the apartment (every article of furniture literally a 'specimen' of something or other,) and in the corner this dark silent medieval woman with her medieval toothache.

Henry James, letter to his sister, Alice James, 10 March 1869

Sample of the *Tulip* motif textile designed by William Morris in 1875.

Critical views

John Ruskin, whose first writings greatly influenced the artists when they formed the Brotherhood, became the theorist of Pre-Raphaelitism after publishing his first famous letter to The Times *in 1851. It sparked an intellectually fruitful dialogue between artists and critics, although their personal relations were sometimes rather strained in both the 'first generation' of Pre-Raphaelite painters, to whom Ruskin is referring in this lecture he gave in 1853, and in the 'second generation', especially Burne-Jones.*

The Pre-Raphaelites explained by John Ruskin

The subject on which I would desire to engage your attention this evening is the nature and probable result of a certain schism which took place a few years ago among our British artists.

This schism, or rather the heresy which led to it, as you are probably aware, was introduced by a small number of very young men; and consists mainly in the assertion that the principles on which art has been taught for these three hundred years back are essentially wrong, and that the principles which ought to guide us are those which prevailed before the time of Raphael; in adopting which, therefore, as their guides, these young men, as a sort of bond of unity among themselves, took the unfortunate and somewhat ludicrous name of 'Pre-Raphaelite' brethren.

You must also be aware that this heresy has been opposed with all the influence and all the bitterness of art and criticism; but that in spite of these the heresy has gained ground, and the pictures painted on these new principles have obtained a most extensive popularity….

[Academy teaching] destroys the greater number of its pupils altogether; it hinders and paralyses the greatest. There is not a living painter whose eminence is not in spite of everything he has been taught from his youth upwards, and who, whatever his eminence may be, has not suffered much injury in the course of his victory….

But the time has at last come for all this to be put an end to; and nothing can well be more extraordinary than the way in which the men have risen who are to do it. Pupils in the same schools, receiving precisely the same instruction

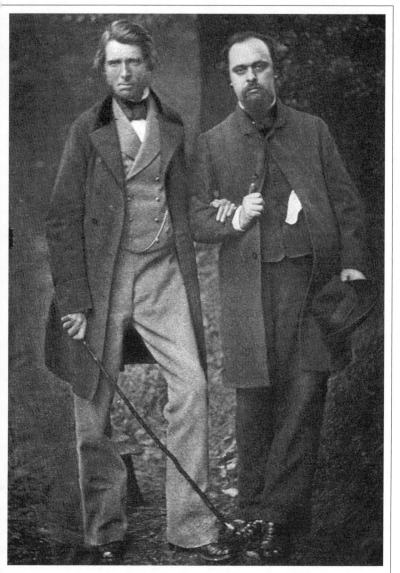

John Ruskin and Dante Gabriel Rossetti, photographed on 29 June 1863 in the garden of Rossetti's house in Cheyne Walk, Chelsea, London.

which for so long a time has paralysed every one of our painters, – these boys agree in disliking to copy the antique statues set before them. They copy them as they are bid, and they copy them better than any one else; they carry off prize after prize, and yet they hate their work. At last they are admitted to study from the life; they find the life very different from the antique, and say so. Their teachers tell them the antique is the best, and they mustn't copy the life. They agree among themselves that they like the life, and that copy it they will. They do copy it faithfully, and their masters forthwith declare them to be lost men. Their fellow-students hiss them whenever they enter the room. They can't help it; they join hands and tacitly resist both the hissing and the instruction. Accidentally, a few prints of the works of Giotto, a few casts from those of Ghiberti, fall into their hands, and they see in these something they never saw before – something intensely and everlastingly true. They examine farther into the matter; they discover for themselves the greater part of what I have laid before you tonight; they form themselves into a body, and enter upon that crusade which has hitherto been victorious. And which will be absolutely and triumphantly victorious. The great mistake which has hitherto prevented the public mind from fully going with them must soon be corrected. That mistake was the supposition that, instead of wishing to recur to the *principles* of the early ages, these men wished to bring back the *ignorance* of the early ages. This notion, grounded first on some hardness in their earlier works, which resulted – as it must always result – from the downright and earnest effort to paint nature as in a looking-glass, was fostered partly by the jealousy of their beaten competitors, and partly by the pure, perverse, and hopeless ignorance of the whole body of art-critics, so-called, connected with the press.

No notion was ever more baseless or more ridiculous. It was asserted that the Pre-Raphaelites did not draw well, in the face of the fact, that the principal member of their body, from the time he entered the schools of the Academy, had literally encumbered himself with the medals, given as prizes for drawing. It was asserted that they did not draw in perspective, by men who themselves knew no more of perspective than they did of astrology; it was asserted that they sinned against the appearances of nature, by men who had never drawn so much as a leaf or a blossom from nature in their lives. And, lastly, when all these calumnies or absurdities would tell no more, and it began to be forced upon men's unwilling belief that the style of the Pre-Raphaelites *was* true and was according to nature, the last forgery invented respecting them is, that they copy photographs. You observe how completely this last piece of malice defeats all the rest. It admits they are true to nature, though only that it may deprive them of all merit in being so. But it may itself be at once refuted by the bold challenge to their opponents to produce a Pre-Raphaelite picture, or anything like one, by themselves copying a photograph.

Let me at once clear your minds from all these doubts, and at once contradict all these calumnies.

Pre-Raphaelitism has but one principle, that of absolute, uncompromising truth in all that it does, obtained by working everything, down to the most minute detail, from nature, and from nature only. Every Pre-Raphaelite landscape background is

painted to the last touch, in the open air, from the thing itself. Every Pre-Raphaelite figure, however studied in expression, is a true portrait of some living person. Every minute accessory is painted in the same manner. And one of the chief reasons for the violent opposition with which the school has been attacked by other artists, is the enormous cost of care and labour which such a system demands from those who adopt it, in contradistinction to the present slovenly and imperfect style.

John Ruskin, 'Pre-Raphaelitism', Lecture IV of *Lectures on Architecture and Painting*, 1854

The English school as seen by Delacroix

Pre-Raphaelite works were first shown on the continent at the 1855 Exposition Universelle in Paris. The admiring comments of the French painter and Anglophile Eugène Delacroix contrast with the rather more ironic assessment of the French man of letters Théophile Gautier. Both texts reflect the response to this art movement in France, which fluctuated between fascination and disgust.

Champrosay, 17 June.
I am thinking, as I get up the next day, a Sunday, of the special charm of the English School. What little I have seen has remained in my mind. They have a

Detail of Millais' *The Order of Release, 1746*, shown at the 1855 Exposition Universelle in Paris.

real delicacy that outshines all the efforts to produce pastiches that we see elsewhere, as in our own sad school. In our case, delicacy is extremely rare: everything seems to have been made with crude tools and, worse still, by obtuse and vulgar minds....

Compare, for example, *The Order of Release, 1746* by Hunt or Millais, I cannot remember which of them it was, with our primitives, our Byzantines, obsessed with style, who, with their eyes always firmly fixed on images from another time, take from them only their stiffness, adding no qualities of their own. This herd of sad mediocrities is enormous; not a grain of truth, of the truth that comes from the soul; nothing comparable to this child sleeping in its mother's arms, with its fine silky hair, its sleep so full of truth (in every detail, even to the red legs and the feet), reflecting a singular power of observation and above all of feeling....

Champrosay, 30 June.
At nine in the morning, to the Jury. I meet Cockerell and Taylor again, both old friends; I spend until about noon there examining the paintings by the English, whom I greatly admire; I am truly amazed by Hunt's sheep.

Eugène Delacroix, *Journal*, 1855

EXPOSITION UNIVERSELLE DE 1855.

BEAUX-ARTS.

A different view: Théophile Gautier

While Mulready follows directly in the line of Hogarth and Wilkie as a true English painter of the old school, reflecting the qualities and weaknesses of his kind, apart from the particular features that distinguish him from his forebears, Mr Millais cannot be associated with any British school, past or present; he is his own man and stands completely isolated within his own originality, as though in an ivory tower; and there, under the vaulted roof and Gothic ribs of the circular room he uses as his studio, lit by a shaft of daylight filtering through the narrow barbican, he works, as though the hour-glass of Time had not shown the passage of four or five centuries since then, with the pious simplicity of Hemmeling, the stained-glass colours of Van Eyck and the scrupulous realism of Holbein. Like certain archaic Germans, Mr Millais would be quite capable of barring Raphael from the gates of paradise, under the pretext that he is too worldly and mannered.

The three pictures by Mr Millais are certainly the most curious ones in the Exposition Universelle and even the most casual visitor cannot but pause before them. Many painters of our times, undecided about so many theories, have sought 'the naive in art', especially on the other side of the Rhine; but none has so courageously carried his system to its logical conclusion. What distinguishes Mr Millais' works from similar endeavours is that he does not confine himself to producing more or less successful facsimiles of old paintings but studies nature with the heart and eyes of a 15th-century artist....

From afar, I must admit, Mr Millais' Ophelia looks a little like a doll drowning in a basin; but come closer and you will be enchanted by a world of wonderful detail. The canvas will come alive and teem with life before your eyes. You will feel as though you are lying by a river bank, gradually noticing the movement of a thousand forms in what you first took for a confused mass of green. If you look closely you will be rewarded by yet another sight, another incident you had not noticed....

In the charming childishness of its naturalism, there is something bizarre about this picture, which is perhaps more appropriate to the subject than any more rational bias. He could not have spent more time on the mad Ophelia; yet you must not believe, from the description, that there is anything Romantic or even Shakespearean about it, in the sense in which we understand these words; it is fantasy created with patience, and the most meticulous botanist would not find in this incredible tangle of plants a single leaf, a single vein, a single petal, a single pistil that is not accurate!

In art, Mr W. Hunt belongs to the same persuasion as Mr Millais. Which is the pupil, which the disciple? Or did they both come to a similar result by pursuing the same ideas? That is outside the scope of our discussion....

Claudio and Isabella is painted by the same curious process we have already noted in Mr Millais' works and which we find it difficult to understand; the rendered and the finished are taken to their ultimate limits, not as a means of achieving that extreme polish that charms the superficial amateur, but to express what is true in its most intimately observed details.

We think that Mr Millais and Mr W. Hunt will set a fashion in England. Their system, in its absolute aspect, is attractive to those who like precision, although we doubt whether our realists will ever imitate them: that would take too much time, awareness, will-power and observation. While doing them the justice they deserve, and which they will perhaps not obtain from the general public, because of their strange appearance and their shocking originality, we fear lest they be defeated in this hand-to-hand battle with nature.

The reason we fear this is a painting by Mr Hunt, entitled *Strayed Sheep*, in which the painter resolutely joins battle with nature and challenges reality to a duel. Sheep that have escaped from their field are roaming among the brambles and rocks and bleating with worry because they cannot find their way back to the barn....

Do you remember a sheep watched over by an old woman, one of the last canvases [Millais] exhibited? Well, that sheep, whose fleece smelled of wool fat and who should have been shorn, was but a quick confused sketch beside Mr Hunt's beasts. – And the landscape? – Stay awhile and contemplate it, it is worth it. – Soon, under the curious green of the lawn bathed in blue shadows and bronzed by the sun, you will observe the slightest undulations of the ground, you will discover the plants flattened by the passage of the flock, the spots where a little trickle of hidden

'Mr Millais' Ophelia looks a little like a doll drowning in a basin; but come closer and you will be enchanted by a world of wonderful detail.' Théophile Gautier, 1855.

water filters through, a labour that would drive a Chinese man mad. Only, because the painter, resolved to make no sacrifice, cannot, however clever he is, mathematically reduce a horizon a league long into one square foot of canvas, the details sometimes take on that exaggerated importance that the microscope imparts to objects and the eye may be drawn as much to a blade of grass as to a tree. It is a curious phenomenon and perhaps there is no other canvas in the Salon that disconcerts the viewer as much as *Strayed Sheep*; the picture that looks the most false is precisely the one that is most true.

Théophile Gautier
Les Beaux-Arts en Europe, 1855

An enthusiastic appreciation of Burne-Jones from a French critic...

French critics did not really begin to appreciate Burne-Jones until 1878, when the painter showed three works, including The Beguiling of Merlin, *at the Exposition Universelle in Paris. Four years later, the critic Ernest Chesneau explained why he was so enthusiastic when he first saw it.*

British painters do not usually seek their themes for heroic works from ancient mythology, but from the legends of their own poets.

This most justifiable form of art inspiration is ably represented by Mr Edward Burne-Jones....

To my mind, Mr Burne-Jones' work gains a singular importance from the fact that he is the only artist whose high gifts in designing, arranging and colouring are equal to his poetical conceptions.

In his three works, *Merlin and Vivien*, from Alfred Tennyson's poem, *Love*

B urne-Jones in front of one of his murals, *The Star of Bethlehem* (c. 1889). Opposite: a self-caricature (1890).

Among the Ruins and *Love the Doctor*, it is his style (a style somewhat overdrawn, it is is true) which alone constitutes their peculiar and exceptional merit. This style is composed of very perfect drawing, a keen faculty of imitation and expression, which vary much in these three works, rich although rather dark colouring, and a faithful carrying out of the most minute and insignificant details; a tiny floweret, a bramble, a door post, as well as an exact delineation of an eyebrow or of a nail on the delicate naked foot of a woman. The value of any work is necessarily greatly increased by the feeling it exhibits and its poetical interpretation, when allied to this devotion to truth and a lofty imagination. But how many of our

young French painters, alas! without consulting truth, vainly strive to acquire these qualities by following traditions handed down from one generation to another….

This style of art is not the less truly poetical in feeling because it is thus imbued with a deference to reality….

Fortunately, after many years of struggle, the English public has at length entered into the spirit of this artistic and poetical movement. The success, although doubtless greatly resulting from the works themselves, is also largely owing to the spirited writings of Mr John Ruskin.

<div align="right">

Ernest Chesneau,
The English School of Painting,
translated by L. N. Etherington, 1885

</div>

To boredom

However, Burne-Jones' work no longer found such favour, in France or elsewhere, by the mid-1890s. Tastes were changing and the French writer and aesthete Robert de Montesquiou foresaw the limits of the art that had attracted French Symbolist and Decadent circles.

Coldly rational in conception, judiciously meticulous in their regular, continuous and brilliant execution, it is in these aspects that Mr Burne-Jones disappoints the viewer enamoured of sorrowful and passionate pictures whose splendour throws a heartrending light over the ruins of unsatisfied endeavours and tormented studies….

This impeccably sure and deliberate execution, this infallible mastery of every detail, give the products of these fairy hands a rather *textile* appearance that leaves little of charm except the plays of colour and certain ingenious details…. Are Burne-Jones' *paintings* any less decorative than his tapestries, his stained glass, his mosaics and his gilt high-reliefs?…

Yes, these paintings by Burne-Jones really are tapestries…. And that is why the best works, those where he allows his nature free play, are his purely decorative works.

un painted masterpieces.

<div align="right">

Robert de Montesquiou,
'Le Spectre Burne-Jones'
(1894) in
Autels privilégiés,
1898

</div>

Rediscovery

After its final decline in the 1890s, Pre-Raphaelitism was rejected and forgotten by the critics in the first half of the 20th century. The Surrealists were alone in daring to go against the current of opinion during the 1930s. There was a revival of interest after the war, with the publication in 1948 of Pre-Raphaelite Painters *by Robin Ironside and John Gere. The movement became highly popular again in the 'Swinging Sixties' in London, with the enthusiasm for what was regarded as the modernity of the Pre-Raphaelites.*

Jeremy Maas

Jeremy Maas was an important London dealer who specialized in Victorian painting. His memoirs evoke the rediscovery, at first timid and then enthusiastic and commercially lucrative, of an art condemned by the previous generations of art lovers and collectors.

The Winter Exhibition of 1951–2 at the Royal Academy, 'The First Hundred Years of the Royal Academy 1769–1868', added further to my education. I have the illustrated souvenir before me as I write, and see now, with some embarrassment, distressingly naive pencilled marginal notes made at the age of twenty-three. Here for the first time I saw Millais' *Isabella*; in the exhibition also were *Mariana* and *Ferdinand Lured by Ariel* (I was later kindly lent this marvellous picture by its present owner for an exhibition). Here also was *The Blind Girl*, for some time now one of my favourite Pre-Raphaelite pictures. Close by were hanging the large version of Ford Madox Brown's *The Pretty Baa-Lambs* and Brett's *The Stonebreaker*. 'Ghastly' I wrote with a line pointing to each. Well, they are still not amongst my favourites, unlike W. S. Burton's *A Wounded Cavalier*, which, together with Wallis' *Chatterton* at the Tate Gallery, I believed then, as I do now, to be amongst the great masterpieces of this school. Others I saw for the first time were Hunt's *The Hireling Shepherd*, one of my two most favourite pictures by this artist (the other being *Valentine Rescuing Sylvia from Proteus*). Hunt, I have always thought, was surely knocked completely off course by going to the Holy Land. In my view the pictures by Hunt which one can enjoy without reservation were for the most part painted before 1854,

the year of his first visit; and the most powerful, and most famous, picture he painted there, *The Scapegoat*, was painted mainly in that year and the next. This too was at this same exhibition. When the picture was first shown at the Royal Academy in 1856, the public could make neither head nor tail of it, and it was considered by everyone, including Ruskin, to be a failure. So my pencilled comment, 'absolutely astonishing', on first seeing the picture was, perhaps, not inappropriate....

On one thing there seems to be a general consensus of agreement: that it was in those early years of the 1960s that the Pre-Raphaelites became ripe for a general revival, not merely as a preference of the general public, but as a subject long overdue for and readily susceptible to academic treatment. This new surge of interest occurred some eight or nine years before the revival of interest in Victorian paintings generally. In the same way that the 1860s were an exciting period in social and art history, so also were the 1960s. There is no question that the Hippy movement and its repercussive influence in England owed much of its imagery, its manner, dress and personal appearance to the Pre-Raphaelite ideal.... It was observed by all of us who were involved with these exhibitions that visitors included increasing numbers of the younger generation, who had begun to resemble the figures in the pictures they had come to see.

Jeremy Maas
'The Pre-Raphaelites: A Personal View' in *Pre-Raphaelite Papers*, 1984

Salvador Dali

Apart from its historical interest, this passage by Salvador Dali is a pertinent analysis of the rather neurotic femininity of an imaginary Pre-Raphaelite.

And how could Salvador Dali not be overwhelmed by the flagrant Surrealism of English Pre-Raphaelitism? The Pre-Raphaelite painters serve us up resplendent women who are at once the most desirable and most frightening ever seen, for they are the kind of beings one would be most terrified and distressed to eat: they are the fleshly phantoms of the 'false memories' of childhood, this is the gelatinous meat of the guiltiest sentimental dreams. Pre-Raphaelitism puts on the table this sensational dish of the eternal feminine, garnished with an exciting and moral hint of highly respectable 'repugnance'. These carnal concretions of excessively ideal women, these feverish and breathless materializations, these limp and floral Ophelias and Beatrices, whom we see through the light of their hair, produce in us the same effect of terror and unequivocally attractive repugnance as the soft underbelly of the butterfly seen through the light of its wings. These women, their eyes heavy with constellated tears, their thick hair heavy with luminous fatigue and halos make a painful and feeble effort to straighten their neck and hold up their head. There is an incurable lassitude in the shoulders collapsed under the weight of the blossoming of this legendary necrophilic spring of which Botticelli vaguely spoke. But Botticelli was still too close to the living flesh of the myth to attain this exhausted, magnificent and incredibly material glory of the entire psychological and lunar 'legend' of the West.

Salvador Dali,
'Le surréalisme spectral de l'éternel féminin préraphaélite' in *Le Minotaure*, no. 8, 1936

A HAPPY EASTER-TIDE.

MAY HE, WHO IS THE WAY, THE TRUTH, THE LIGHT,
SHED O'ER YOUR DAILY PATH HIS RADIANCE BRIGHT,
YOUR FOOTSTEPS GUIDE THROUGH DAYS
OF CALM OR STRESS
AND FILL YOUR HEART WITH JOY AND HAPPINESS.

Greetings card, c. 1900

The immense popularity of Hunt's *The Light of the World* gave rise to countless pious images of it.

Peter Greenaway

The English film director Peter Greenaway drew much of the inspiration for his film Drowning by Numbers *(1988) from Pre-Raphaelite landscape paintings. He justified this action by analysing the wealth of collective cultural and visual references underlying the Pre-Raphaelite representation of the English countryside.*

Millais and Hunt were Pre-Raphaelites but the subjects and the morals are Victorian English. After 1860, the interest in this particular genre of dramatized 'moral' landscape diminished and a great many of these paintings have long been out of favour. They have been, are still are, considered to be too literary. Some consider them 'overwrought' and to have 'an excess of sentiment'. Contemporary painting movements in France have stolen the limelight.… What these paintings do have is a hypersensitive and scrupulously observed depiction of light and weather – especially sunlight where the concern for an accurate rendition of the seen world is also so intense as to be painful to contemplate. Their intention also was always to point to a moral. Sometimes this moral is not hard to fathom or provocative enough to disturb. Often the moral is problematic and complex. Sometimes it is enigmatic enough to persistently intrigue. Holman Hunt is a maker of such enigmas.

There is a painting [*The Hireling Shepherd*; see page 38] by the English painter William Holman Hunt that used to be reproduced with unfailing regularity in books and periodicals in the years after the Second World War. I was introduced to it in the late 1950s and was told to believe that it was a bad painting. The most vitriolic accusation was that it was 'narrative' and 'literary'. I have come to think that this painting is no more 'narrative' than much painted by, for example, Vermeer, and I suspect that in the 1950s at any rate, there were other contributing factors to the painting's bad press – its current ubiquity in poor reproduction, the general dismissal of things Victorian, and a reaction to the jingoistic concern for 'England's green and pleasant land' which it was often used to represent. It is also a painting that is unashamedly figurative – perhaps a criminal offence after England had finally and begrudgingly accepted the Continental experiments.

Peter Greenaway
Fear of Drowning by Numbers
1989

Pre-Raphaelite painting and photography

Aaron Scharf was the first historian of photography to make a precise analysis of the relationship between painting and photography in the 19th century. His reflections on the Pre-Raphaelites raise questions concerning the painters' direct use of photography and the influence of photography on the composition and aesthetics of Pre-Raphaelite paintings.

Ruskin's injunctions about painting from nature alone seem to contradict his other recommendations that photographs could be of some limited advantage to artists. But he meant them to be used for study or drawing, never to be painted from directly. For photographs revealed certain subtleties of contour and tone which might escape the eye, and he admitted that much could be learned from them. Their convenience, when working up a painting in the studio, should not be underestimated....

Ford Madox Brown, for example, wrote in his diary (12 November 1847) that he 'went to see Mark Anthony about a Daguerreotype: think of having some struck off for the figures in the picture, to save time'. The camera was a convenient means of collecting studies of costumes and models and could save the artist the cost of several sittings. Edward Burne-Jones and William Morris posed a model in a suit of armour, 'to be photographed in various positions'....

Rossetti owned many photographs of Jane Morris which may have served him for drawings and paintings in which she is the model....

In Millais' portrait of Ruskin the subject stands on a rocky ledge before a background wealth of carefully delineated natural forms, on which the figure appears to be superimposed. Not so much as a shadow unites it to its surroundings. In his *Autumn Leaves*...the foreground objects appear separated from the background, the incisive, light contours around the figures cut them off from the distant landscape. Ruskin noted in 1870 that some photographs 'reveal a sharp line of light round the edges of dark objects' and earlier, in 1859, methods for avoiding it in photographs were discussed.

Aaron Scharf,
'The Pre-Raphaelites' Use
of Photography'
in *Art and Photography*, 1968

Photograph of Thomas Carlyle, a study for Ford Madox Brown's *Work*.

FURTHER READING

CATALOGUES

Parris, Leslie (ed.), *The Pre-Raphaelites*,
Tate Gallery Publications, 1984

ESSAYS

Harding, Ellen (ed.), *Re-framing the Pre-
Raphaelites: Historical and Theoretical Essays*,
1995
Parris, Leslie, *Pre-Raphaelite Papers*, 1984

GENERAL WORKS

Barringer, Tim, *The Pre-Raphaelites*, 1998
Doughty, Oswald, *A Victorian Romantic:
Dante Gabriel Rossetti*, 1949
Grieve, Alistair, *The Art of Dante Gabriel Rossetti*,
1976
Hilton, Timothy, *The Pre-Raphaelites*, 1970
Hueffer, Ford Madox, *Ford Madox Brown:
A Record of His Life and Work*, 1896
Hunt, William Holman, *Pre-Raphaelitism and
the Pre-Raphaelite Brotherhood*, 1905
Ironside, Robin, and John Gere, *Pre-Raphaelite
Painters*, 1948
Marsh, Jan, *Pre-Raphaelite Women*, 1987
Spalding, Frances, *Magnificent Dreams.
Burne-Jones and the Late Victorians*, 1978

Staley, Allen, *The Pre-Raphaelite Landscape*, 1973
Treuherz, Julian, *Victorian Painting*, 1993
Warner, Malcolm, *The Victorians, British Painting
1837–1901*, 1997
Wildman, Stephen, *Visions of Love and Life,
Pre-Raphaelite Art from the Birmingham
Collection*, 1995
Wilton, Andrew, and Robert Upstone, *The Age
of Rossetti, Burne-Jones and Watts, Symbolism
in Britain 1860–1910*, 1997
Wood, Christopher, *The Pre-Raphaelites*, 1981

LETTERS AND WRITINGS

Burne-Jones, Georgina, *Memorials of Edward
Burne-Jones*, 1904
Doughty, Oswald, and John Robert Wahl (eds.),
Letters of Dante Gabriel Rossetti, 1965–7
Hares-Stryker, Carolyn, *An Anthology of
Pre-Raphaelite Writings*, 1997
Millais, John Guille, *The Life and Letters of Sir
John Everett Millais*, 1899
Rossetti, William Michael (ed.), *Dante Gabriel
Rossetti: His Family Letters With a Memoir*, 1895
— (ed.), *Pre-Raphaelite Diaries and Letters*, 1900
Surtees, Virginia, *The Paintings and Drawings
of Dante Gabriel Rossetti (1828–1882).
A Catalogue Raisonné*, 1971
—, *The Diary of Ford Madox Brown*, 1981

LIST OF MUSEUMS

*Most Pre-Raphaelite works can be found in the
following collections:*

PUERTO RICO

Ponce
Museo de Arte

UK

Bexleyheath (Kent)
Red House
Birmingham
Birmingham Museum and Art Gallery
Cambridge
Fitzwilliam Museum
Liverpool
Lady Lever Art Gallery
Walker Art Gallery

London
Tate Gallery
Victoria and Albert Museum
William Morris Gallery
Manchester
Manchester City Art Galleries
Oxford
Ashmolean Museum
Kelmscott Manor, Oxfordshire
Oxford Union Library (frescoes)
Southampton
Southampton City Art Gallery

USA

New Haven (Connecticut)
Yale Center for British Art
Wilmington (Delaware)
Delaware Art Museum

LIST OF ILLUSTRATIONS

The following abbreviations have been used:
a above; *b* below; *c* centre; *l* left; *r* right; AM
Visitors of the Ashmolean Museum, Oxford;
BMAG Birmingham Museum and Art Gallery;
LLAG Board of Trustees of the National Museums
and Galleries of Merseyside (Lady Lever Art
Gallery), Liverpool; LWAG Board of Trustees of
the National Museums and Galleries of Merseyside
(Walker Art Gallery), Liverpool; MAG
Manchester City Art Galleries; TG Tate Gallery,
London.

COVER

Front John Everett Millais. *Ophelia* (detail),
1851–2. Oil on canvas, 76.2 × 111.8 cm
(30 × 44 in.). © Tate Gallery, London 2000.
TG
Spine Dante Gabriel Rossetti. *Astarte Syriaca*
(detail), 1877. Oil on canvas, 182.9 × 106.7 cm
(72 × 42 in.). MAG
Back Edward Burne-Jones. *The Golden Stairs*
(detail), 1876–80. Oil on canvas, 277 × 177
cm (109 × 46 in.). © Tate Gallery, London 2000.
TG

OPENING

1 Dante Gabriel Rossetti. *The Bower Meadow*
(detail), 1871–2. Oil on canvas, 85.1 × 67.3 cm
(33½ × 26½ in.). MAG
2 Charles Allston Collins. *Convent Thoughts*
(detail), 1850–1. Oil on canvas, 82.6 × 57.8 cm
(32½ × 22¾ in.). AM
3 Dante Gabriel Rossetti. *Ecce Ancilla Domini!*
(detail), 1849–50. Oil on canvas, 72.6 × 41.9 cm
(28⅞ × 16½ in.). TG
4 John Everett Millais. *Mariana* (detail), 1850–1.
Oil on panel, 59.7 × 49.5 cm (23½ × 19½ in.).
TG
5 Arthur Hughes. *April Love* (detail), 1855. Oil
on canvas, 88.9 × 49.5 cm (33 × 19½ in.). TG
6 William Morris. *La Belle Iseult*, also known
as *Queen Guenevere* (detail), 1858. Oil on canvas,
71 × 50 cm (28½ × 20 in.). TG
7 Edward Burne-Jones. *The Beguiling of Merlin*
(detail), 1870–4. Oil on canvas, 186 × 110.5 cm
(73 × 43½ in.). LLAG
9 Dante Gabriel Rossetti. *The Bower Meadow*,
1871–2. Oil on canvas, 85.1 × 67.3 cm (33½ ×
26½ in.). MAG

CHAPTER 1

10 William Holman Hunt. *The Eve of St Agnes*
(detail), 1848. Oil on canvas, 77.5 × 113 cm
(30½ × 44½ in.). Guildhall Art Gallery,
Corporation of London
11 Arthur Hughes, after a sketch by William
Holman Hunt. *The Pre-Raphaelite Brotherhood*,
1848, in William Holman Hunt, *Pre-Raphaelitism
and the Pre-Raphaelite Brotherhood*, 1905
12a William Holman Hunt. *Portrait of Millais*,
1853. Drawing. Private collection
12b Dante Gabriel Rossetti. *Self-portrait*, 1847.
Drawing. National Portrait Gallery, London
13a The National Gallery, Trafalgar Square.
Engraving by R. Sands, after T. Allom, 1836.
Peter Jackson Collection
13b Dante Gabriel Rossetti. *Portrait of Holman
Hunt*. Drawing. BMAG
14 Raphael. *The Transfiguration*, c. 1518.
Altarpiece. Vatican Museum, Rome
14–5 David Wilkie. *Grace Before Meat*, 1839. Oil
on canvas, 101 × 127 cm (39¾ × 50 in.). BMAG
15 Sir Joshua Reynolds. Frontispiece to *The Works
of Sir Joshua Reynolds*, 1801. Engraving
16l Drawings by Charles Barry for the Houses of
Parliament. Watercolour. Drawings Collection,
Royal Institute of British Architects, London
16r The royal throne, House of Lords, Palace of
Westminster, London. Photograph
17 Joseph Nash. *The House of Lords*, 1851.
Watercolour. Palace of Westminster Art Collection
18a Johann Friedrich Overbeck. *Italia and
Germania*, 1828. Oil on canvas, 95 × 105 cm
(37½ × 41¼ in.). Gemäldegalerie, Neue Meister,
Dresden
18b Giusto de' Menabuoi. *The Coronation of
the Virgin* (detail), c. 1380. Tempera on poplar,
central panel 48 × 25 cm (19 × 10 in.). National
Gallery, London
19 Ford Madox Brown. *Chaucer at the Court
of King Edward III*, 1845–51. Oil on canvas, 372
× 296 cm (146½ × 116½ in.). Art Gallery of
New South Wales, Sydney
20 John Ruskin. *Study of Gneiss Rock at Glenfinlas*,
1853. Watercolour, 45 × 32.4 cm (17¾ × 12¾
in.). AM
21a Title page of John Ruskin's *Modern Painters*
21b John Ruskin. *Self-Portrait*, 1854. Water-
colour. Frontispiece to W. G. Collingwood, *Life
of Ruskin*, 1893

CHAPTER 2

CHAPTER 3

52 Dante Gabriel Rossetti. *Found*, 1854–81. Oil on canvas, 91.4 × 80 cm (36 × 31½ in.). Delaware Art Museum, Wilmington, Delaware, USA

53 Ford Madox Brown. *Take Your Son, Sir!*, 1851, 1856–7. Oil on paper, mounted on canvas, 70.4 × 38.1 cm (27¾ × 15 in.). TG

54 William Holman Hunt. *The Awakening Conscience*, 1853–4, retouched 1856, 1857, 1864, 1879–80, 1886. Oil on canvas, 76.2 × 55.9 cm (30 × 22 in.). TG

55a William Holman Hunt. *The Light of the World*, 1851–3. Oil on canvas, 125.5 × 59.8 cm (49⅜ × 23½ in.). Keble College, Oxford

55b William Holman Hunt. Preliminary drawing for *The Light of the World*, 1851–3. AM

56 W. H. Hunt. *The Scapegoat*, 1856. Oil on canvas, 85.7 × 138.5 cm (33¾ × 54¼ in.). LLAG

56–7 William Holman Hunt. *Our English Coasts*, also known as *Strayed Sheep*, 1852. Oil on canvas, 43.2 × 58.4 cm (17 × 23 in.). TG

58 John Everett Millais. *The Order of Release, 1746*, 1852–3. Oil on canvas, 102.9 × 73.7 cm (40½ × 29 in.). TG

58–9 John Everett Millais. *John Ruskin*, 1853–4. Oil on canvas, 78.7 × 68 cm (31 × 26¾ in.). Private collection

60a John Everett Millais. *Portrait of Thomas Combe*, 1850. Oil on panel, 32 × 27 cm (7⅛ × 6⅞). AM

60b William Shakespeare Burton. *The Wounded Cavalier*, 1855. Oil on canvas, 88.9 × 104.1 cm (35 × 41 in.). Guildhall Art Gallery, Corporation of London

61 Arthur Hughes. *April Love*, 1855. Oil on canvas, 88.9 × 49.5 cm (35 × 19½ in.). TG

CHAPTER 4

62 Dante Gabriel Rossetti. *Monna Vanna*, 1866. Oil on canvas, 88.9 × 86.4 cm (35 × 34 in.). TG

63 Max Beerbohm. Caricature of *Topsy and Ned Jones* [William Morris and Edward Burne-Jones] *Settled on the Settle in Red Lion Square*, 1916. Watercolour and pencil, 31 × 39.4 cm (12¼ × 15½ in.). TG

64a Photograph of Burne-Jones aged forty-one, 1874. Reproduced in Georgina Burne-Jones, *Memorials of Edward Burne-Jones*, 1904

64b Photograph of William Morris aged twenty-three, 1857. Reproduced in Georgina Burne-Jones, *Memorials of Edward Burne-Jones*, 1904

65 Dante Gabriel Rossetti. *The First Anniversary of the Death of Beatrice*, 1853. Watercolour, 42 × 61 cm (16½ × 24 in.). AM

66 Edward Burne-Jones. *The Knight's Farewell*, 1858. Pen and ink and grey wash on vellum, 15.9 × 19.1 cm (6¼ × 7½ in.). AM

67 Dante Gabriel Rossetti. Illustration to Tennyson's 'The Lady of Shalott', published by Edward Moxon in 1857

68a Dante Gabriel Rossetti. Study for *Sir Launcelot's Vision of the Sanc Greal*, 1857. Watercolour, 71 × 107 cm (28 × 42⅛ in.). AM

68b Photograph of Algernon Charles Swinburne, aged twenty-six, 1863. Reproduced in Georgina Burne-Jones, *Memorials of Edward Burne-Jones*, 1904

69 Interior of the Oxford Union debating hall, now the library. Photograph

70 Edward Burne-Jones. *The Merciful Knight*, 1863. Watercolour and gouache, 100.3 × 69.2 cm (39½ × 27¼ in.). BMAG

71 William Morris. *La Belle Iseult*, also known as *Queen Gueneuere* (detail), 1858. Oil on canvas, 71 × 50 cm (28½ × 20 in.). TG

72 John Everett Millais. *The Blind Girl*, 1854–6. Oil on canvas, 82.6 × 62.2 cm (33½ × 24½ in.). BMAG

72–3 John Everett Millais. *Spring*, also known as *Apple Blossoms*, 1856–9. Oil on canvas, 110.5 × 172.7 cm (43½ × 68 in.). LLAG

73 John Everett Millais. *Autumn Leaves*, 1855–6. Oil on canvas, 104.1 × 73.6 cm (41 × 29 in.). MAG

74a Dante Gabriel Rossetti. *Lizzie Siddal*, 1855. Pencil. BMAG

74b Elizabeth Siddal. *Clerk Saunders*, 1857. Watercolour and gouache, 69.8 × 41.9 cm (27½ × 16½ in.). Fitzwilliam Museum, Cambridge

75 Edward Burne-Jones. *Sidonia von Bork*, 1860. Watercolour with bodycolour, 33 × 17 cm (13 × 6¾ in.). TG

76a Julia Margaret Cameron. *Call, I Follow*, 1867. Photograph. Royal Photographic Society, Bath

76b Dante Gabriel Rossetti. *Beata Beatrix*, 1864–70. Oil on canvas, 86.4 × 66 cm (34 × 26 in.). TG

77 Dante Gabriel Rossetti. *Bocca Baciata*, 1859. Oil on panel, 33.7 × 30.5 cm (13¼ × 12 in.). Museum of Fine Arts, Boston. Gift of James Lawrence

78 Photograph of Jane Morris taken by D. G. Rossetti in 1865. St Brides Printing Library, Corporation of London

79 Dante Gabriel Rossetti. *Proserpine*, 1873–7. Oil on canvas, 119.5 × 57.8 cm (42 × 22 in.). TG

INDEX OF WORKS BY ARTIST

INDEX

PHOTO CREDITS

Laurence des Cars
is curator at the Musée d'Orsay, Paris, where she
organized the exhibitions on Courbet (1996) and on
Jean-Paul Laurens (1997). She also helped organized
the Edward Burne-Jones retrospective at
the Metropolitan Museum of Art, New York,
the Birmingham Museum and Art Gallery
and the Musée d'Orsay in 1998 and 1999.

For Louis

Translated from the French by Francisca Garvie

First published in the United Kingdom in 2000 by
Thames & Hudson Ltd, 181A High Holborn,
London WC1V 7QX

English translation © 2000 Thames & Hudson Ltd,
London

© 1999 Gallimard/Réunion des Musées nationaux

British Library Cataloguing-in-Publication Data

A catalogue record for this book is available
from the British Library

ISBN 0–500–30100–X

Printed and bound in Italy
by Editoriale Lloyd, Trieste